IMAGES
of America

SOUTH JERSEY
FARMING

IMAGES
of America

SOUTH JERSEY
FARMING

Cheryl L. Baisden

ARCADIA
PUBLISHING

Published by Arcadia Publishing
Charleston SC, Chicago IL, Portsmouth NH, San Francisco CA

Printed in the United States of America

Library of Congress Catalog Card Number: 2005939054

For all general information contact Arcadia Publishing at:
Telephone 843-853-2070
Fax 843-853-0044
E-mail sales@arcadiapublishing.com
For customer service and orders:
Toll-Free 1-888-313-2665

Visit us on the Internet at www.arcadiapublishing.com

*This book is dedicated to the determined farmers
who continue working the land in South Jersey, a rare breed
as the region rapidly shifts from raising crops
to sprouting housing developments.*

CONTENTS

ACKNOWLEDGMENTS

South Jersey Farming would not have been possible without the support of numerous South Jersey residents and organizations that continue to care about the region's great farming tradition. A special thanks to Seabrook Farms Educational and Cultural Center for providing access to their archives and assisting in obtaining material for this book, and to the New Jersey Conservation Foundation for lending their one-of-a-kind slides for reproduction.

INTRODUCTION

By 1876, the year Abraham Browning christened it the Garden State, New Jersey was already renowned as a leader in the farming industry. Sandwiched between the two major cities of New York and Philadelphia, the state was, according to Browning, "like an immense barrel, filled with good things to eat and open at both ends, with Pennsylvanians grabbing from one end and the New Yorkers from the other." At the time, nearly two-thirds of the state's acreage was dedicated to farming. Today, while ranking as the nation's most densely populated state, New Jersey's available farmland has dropped dramatically, but the state—particularly the southern counties of Atlantic, Burlington, Camden, Cape May, Cumberland, Gloucester, and Salem—continues to live up to its early reputation. Thanks to South Jersey's continued commitment to agriculture, in 2005, New Jersey ranked second in the nation in blueberry production, third in cranberries and peppers, and fourth in peaches.

From its early farming days, South Jersey was recognized as an agricultural innovator, improving upon everything from soil preparation to produce processing. It was here that the nation's first cast-iron plow was invented, the blueberry was first cultivated, grape juice was invented, the first frozen vegetables were processed, and the Mason jar was developed and manufactured. But while South Jersey's agricultural history is filled with firsts, it was the commitment of the farmers and hired laborers that made the region great.

City dwellers were lured to the area by real estate developers possessing a vision of South Jersey as a vastly untapped resource for farming. European Jews, denied the right to own land in their homeland, found the area welcoming as well. Countless immigrant families, migrant workers, and tenant farmers labored in South Jersey's fields, often living in poor conditions and working long hours in the hot sun to harvest crops and provide for their families.

To those speeding down the New Jersey Turnpike, Garden State Parkway, or the area's congested highways today, South Jersey's agricultural spirit may seem little more than a faint memory, if that. But among the growing housing developments, strip malls, and industrial parks, some of the region's farming community still remains vibrant and productive. Hopefully the day will never come when these, too, disappear.

One

FARMING FIRSTS

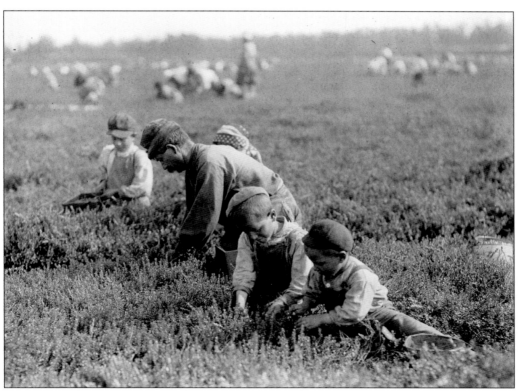

Before the advent of heavy machinery designed to plow, plant, fertilize, and harvest crops, farming was an extremely labor-intensive business, dependent upon the entire family and a large number of seasonal workers. For South Jersey farmers, the immigrant population of Camden, Philadelphia, and Delaware offered an endless source of cheap labor to harvest everything from apples to zucchini. (Courtesy Library of Congress, Prints and Photographs Division.)

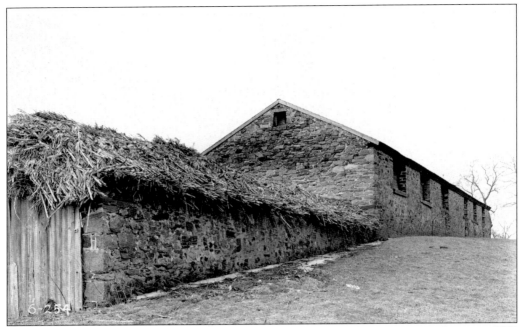

Burlington County's Charles Newbold patented America's first cast-iron plow in 1797, demonstrating the laborsaving device before a large but unimpressed crowd of farmers at this local farm. Few farmers took to the solid cast-iron contraption due to the belief that iron poisoned the soil and caused weeds to grow. This photograph shows the sturdy stone barn on John Black Jr.'s farm at Newbold's Corner in Eayrestown. (Courtesy Library of Congress, Historic American Buildings Survey.)

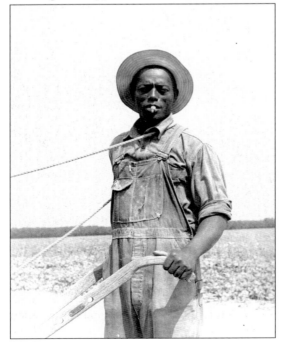

Newbold's plow included a solid piece of cast iron with a wooden beam and handles. Ten years later, Burlington County's David Peacock marketed a successful three-piece version. Beyond the changing times, the plow became popular because its point could be replaced if damaged by a root or rock. The Newbold plow had no replaceable parts. The basic design behind these early plows was still being used when this photograph was taken approximately 135 years later. (Courtesy Seabrook Farms Educational and Cultural Center.)

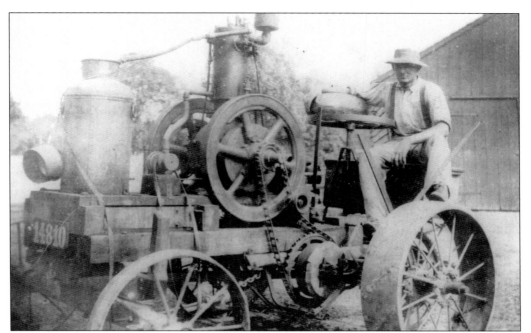

Plows were not the only laborsaving farming tools believed to be dangerous to the soil when they were first introduced. Tractors were greeted with suspicion at the beginning of the 20th century, making them slow to replace the horse-drawn plow. Alvin Crispin, pictured here in 1904 atop his homemade creation, made local history as the first farmer in Gloucester and Camden Counties to use a tractor. (Courtesy Gloucester County Historical Society.)

Burlington County resident Charles Read, owner of the Batsto iron ore operation pictured here, was one of the nation's early agriculturalists. In the latter part of the 18th century, when land was so readily available in South Jersey that farmers gave little thought to long-term preservation of the rich soil, he reportedly was the first in the nation to write about farmland conservation and the need to experiment with replenishing nutrients in order to maintain soil productivity. (Courtesy Library of Congress, Historic American Buildings Survey.)

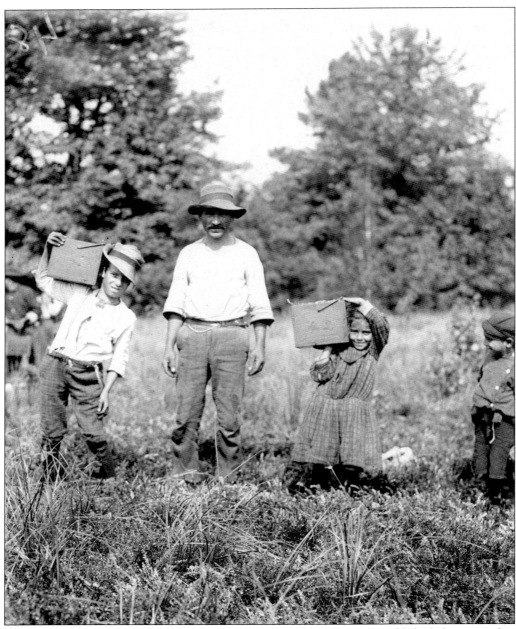

Cranberries only grew wild in New Jersey before Benjamin Thomas established the state's first cranberry bog in Burlington County around 1835. Harvesting cranberries was a backbreaking job that was well suited for the little hands of young children, who regularly joined their parents in the bogs during harvest time. (Courtesy Library of Congress, Prints and Photographs Division.)

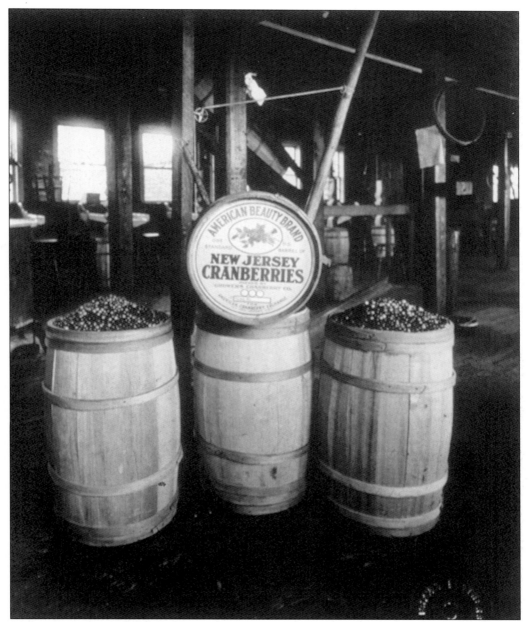

The American Cranberry Exchange, established in 1862, was the first organized agricultural commodity association in the country. Whitesbog cranberries, packaged here under the American Beauty Brand name, were distributed through the exchange. (Courtesy New Jersey Conservation Foundation.)

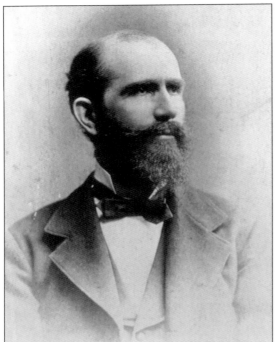

J. J. White was a leading cranberry grower in Burlington County, establishing his 3,000-acre enterprise known as Whitesbog in the 1860s. But it was his daughter Elizabeth who brought agricultural glory to the family with her experimentation with wild blueberries. (Courtesy New Jersey Conservation Foundation.)

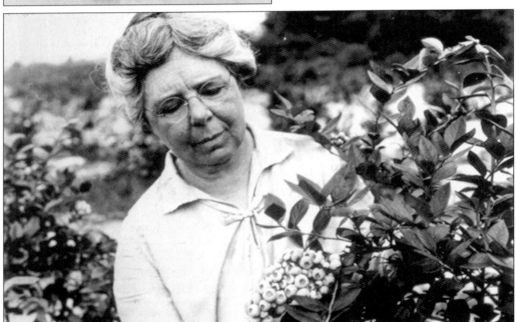

Elizabeth White began working with blueberries by cultivating the wild berries growing on the edge of the family's cranberry bogs and paying neighbors to collect different varieties. Armed with her research data, she collaborated with scientist Frederick Colville to produce the first cultivated blueberry in 1916, and shipped the first commercial batch in the United States that same year. Today New Jersey is the second largest producer of blueberries in the country. (Courtesy New Jersey Conservation Foundation.)

To All Wanting
FARMS!

Village Lots!
Half-Acre Lots!
Acre Lots!
Two-Acre Lots!
Three-Acre Lots!
Four-Acre Lots!
Five-Acre Lots!
Ten-Acre Lots!

All Sizes of Lots to One Hundred-Acre Lots!

All in the Village of

VINELAND!

Or near by it. Mostly cleared, grubbed, plowed and under a good state of cultivation; and much of it planted to choicest kinds of Fruit-trees, Peach trees, Pear, Apple, Cherry, and Quince trees---also, Strawberries, Raspberries, Blackberries, Grapes, &c. &c.

I have also **700 Acres** of Land in the beautiful valley of the

TREMPELEAU RIVER, WISCONSIN.

The very finest selections made in the Valley, when brought into market, that I will sell or exchange for Houses and Lots in Vineland.

Call and examine particulars at my office, South-East corner of Landis and East Avenues.

JOHN GAGE.

Vineland January 1st 1866.

Legend has it that land developer Charles Landis launched his movement to settle the region he named Vineland by driving a stake into the ground in 1861, and proclaiming that he planned to "build a city and an agricultural and fruit-growing colony around it." Within five years, when this advertisement was being distributed to attract prospective buyers, close to 5,500 people already had settled approximately 20,000 acres in Vineland. According to the advertisement, most of the available lots had now been cleared, plowed, and planted with a variety of fruit trees and plants, including the then-popular pear-shaped quince.

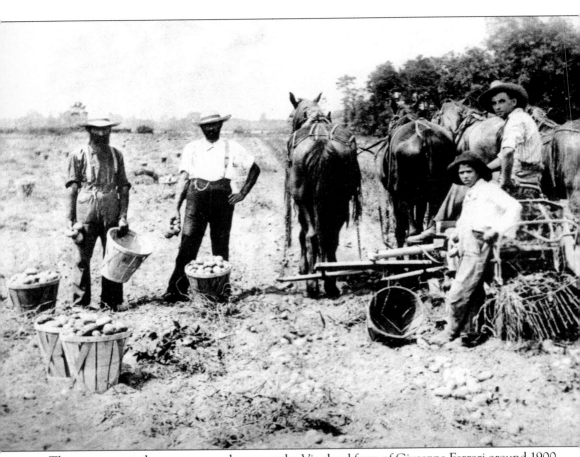

The sweet potato harvest gets underway at the Vineland farm of Giuseppe Ferrari around 1900. Italian immigrants recruited by Landis established small, productive farms in Vineland, where the soil was previously believed to be too sandy to yield quality crops.

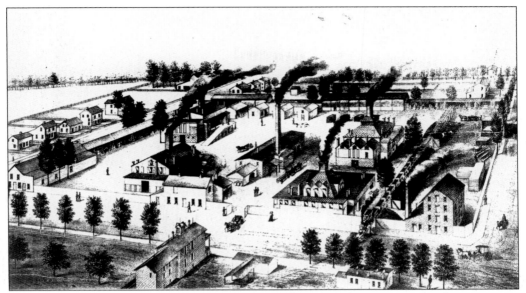

The invention of the Mason jar by John L. Mason, who received a patent on the glass container and lid in 1858, freed farm families from reliance on pickling, drying, and smoking foods for the winter. Mason jars were originally manufactured by Atlantic Glass Works in Crowleytown in Burlington County and later were made by three different factories, including Whitney Glass Works in Glassboro, pictured here.

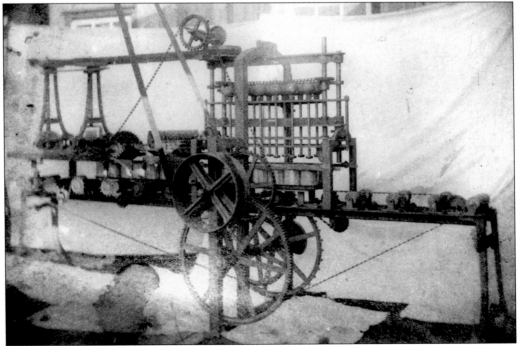

Edward Haines of Woodstown invented this contraption in 1885. Called the Topper and Wiper, it was reported to be the first power-operated tomato canner. (Courtesy Gloucester County Historical Society.)

Dr. John Dorrance, who in 1897 developed condensed soup while working for the Joseph Campbell Company (later renamed the Campbell Soup Company), grew tomatoes on this experimental farm in Cinnaminson surrounding his family home. Tomato farmers were provided with seeds from these fields to guarantee uniformity as the company worked to develop the perfect soup tomato. (Courtesy Campbell Soup Company.)

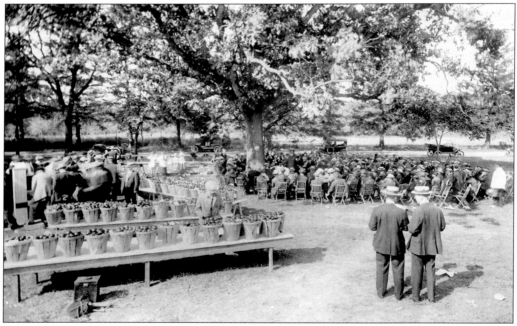

Campbell Soup Company's tomato suppliers exhibit their best at a 1913 or 1914 gathering attended by company executives and U.S. Department of Agriculture experts, who discussed the benefits of spraying and fertilizing crops as well as ways to prevent blight. Prizes were awarded for the best basket of tomatoes, and Campbell's executives urged attending farmers to focus on growing early varieties as well as late ones to extend the growing season. (Courtesy Campbell Soup Company.)

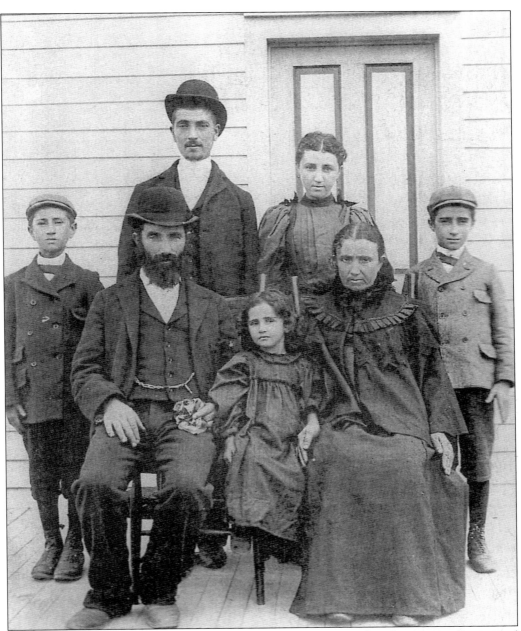

In 1882, philanthropist Baron de Hirsch rescued 43 Jewish families from czarist Russia and resettled them in a farming village he financed near Vineland. Temporarily housed in U.S. Army tents, they soon established a vibrant community named Alliance. The nearby Jewish farming settlements of Woodbine, Carmel, Norma, Bortmanville, Hebron, Mizpah, and Rosenhayn soon followed. This Jewish farm family, photographed around 1890 in Vineland, is dressed for Sabbath observance. (Courtesy Gertrude Dubrovsky.)

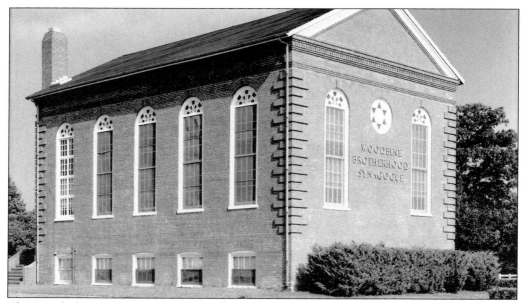

The Jewish farming colony of Woodbine was settled in 1891 by 62 families, each granted 30 acres—complete with a farmhouse, outbuildings, and stock—for $1,200. They later built the Woodbine Brotherhood Synagogue and in 1894, founded the Baron de Hirsch School. The Cape May County facility was the first secondary agricultural school in the United States and was originally attended by about 100 potential Jewish farmers. (Courtesy Library of Congress, Historic American Buildings Survey.)

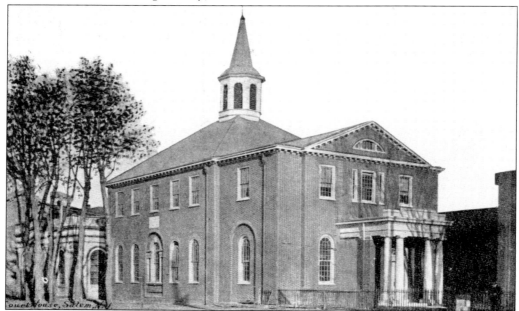

Legend has it that Col. Robert Gibbons Johnson imported the tomato in 1820, when most farmers in the region considered it worthless and possibly poisonous. After he survived eating a juicy red tomato on the steps of the Salem County Courthouse, pictured here, tomatoes went on to become one of South Jersey's most prolific produce.

Cape May County's southern exposure prompted several crop experiments over the years, including efforts to grow licorice and mulberry, pictured here. Mulberry trees yielded dark purple mulberry fruit, and the leaves were most commonly used as a source of food for silkworms. (Courtesy Library of Congress, Prints and Photographs Division.)

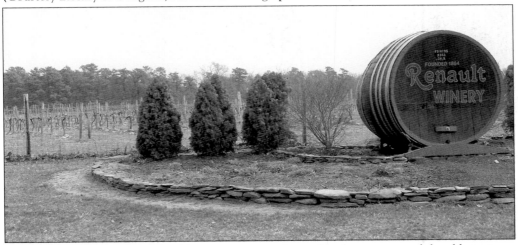

Founded in 1864, Renault is the oldest estate-grown vineyard in the country and the oldest winery in the state. During Prohibition, the Egg Harbor winery operated under a government permit authorizing the manufacture of wine for religious and medicinal purposes. The wine, which had an alcohol content of a whopping 22 percent (today's alcohol content ranges from 9 to 14 percent), was sold in drugstores nationally for 14 years under the label Renault Wine Tonic.

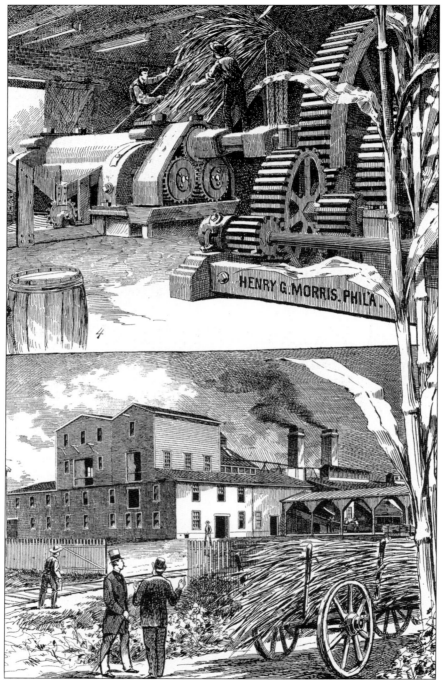

In the late 1880s, a group of Philadelphia promoters planted 2,000 acres of sugar cane in Cape May County. They were motivated by state bounties offered for growing and refining the crop. The Rio Grande Sugar Company, seen here in an 1883 *New York Daily Graphic* illustration, refined 76,000 pounds of sugar and produced 87,000 gallons of syrup in 1884. The following year, the operation folded when the state failed to fund the project.

New-Jersey State Agricultural Society

RST FAIR AT CAMDEN, N. J., SEPT. 18TH TO 21ST, '5

OFFICERS.

President.---WILLIAM P. ROBESON, Belvidere, Warren County.
Vice Presidents.---James Campbell, Weston, Somerset Co.; John
ckler, Carpenter's Landing, Gloucester Co.; Charles M. Saxton, Orang
ssex Co; Thos. Bell, Eatontown, Monmouth Co; Dr. J. Marshal Pau
lvidere, Warren co.
Corresponding Secretary, J H Frazee, Somerville, Somerset Co.
Recording Secretary, Isaac R Cornell, Weston, Somerset Co.
Treasurer, Jos. G Brearley, Trenton, Mercer Co.
Executive Committee, Martin J Ryerson, Lewis Dunn, Peter
uffman, Benjamin Haines, Jacob M Troth, William Kitchell, John
eacon, William Torrey, J C Taylor, Charles Knight, James Buckele
d William B Otis.

SUPERINTENDENTS.

General Superintendent, THOMAS BELL.
Class 1, (*Cattle*) Geo. Hartshorne. Class 2, (*Horses*) Nathaniel S Ru
lass 3, (*Sheep, Swine & Poultry*) John B Edgar. Class 4 (*Implemen*
Machinery) Dr C T Harris. Class 5 (*Flour, Grain &c*) Edgar Smit
lass 6 (*Domestic Manufactures*) William Bettle. Class 7 (*Flower*
ants & Designs) Edward Bettle. Class 8 (*Silver Ware, Cutlery &*

The New Jersey Agricultural Society, founded in 1781, was the first organization of its kind in the country. The society was established to preserve and enhance agriculture, farming, and related activities in the state. This 1855 poster announces the first society-sponsored fair in Camden. (Courtesy Camden County Historical Society.)

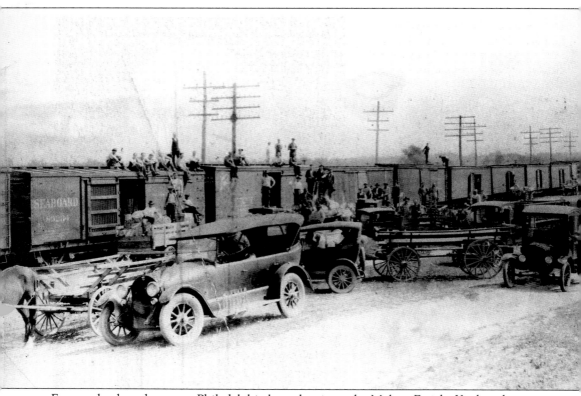

Farmers load produce on a Philadelphia-bound train at the Malaga Freight Yard in the summer of 1922, marking their first shipment as members of the Newfield Farmers Association. In the 1920s, South Jersey farmers began forming co-ops to sell their crops at auction, giving them more control over pricing of their produce, which previously was shipped to Philadelphia and New York without a payment guarantee. Instead, the final price was determined by buyers at the time of delivery. (Courtesy Gloucester County Historical Society.)

Dr. Thomas B. Welch created his famous grape juice in Vineland in 1925, as an unfermented wine using concord grapes grown at his own vineyard. His juice-making process utilized the pasteurizing techniques developed by Louis Pasteur for milk. (Courtesy Welch's.)

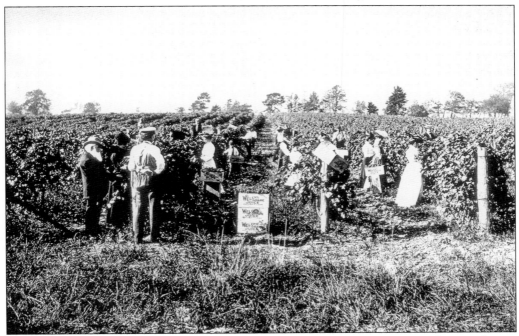

Dr. Welch (left) inspects his vineyards as workers begin harvesting ripe concord grapes for use at his juice factory. (Courtesy Welch's.)

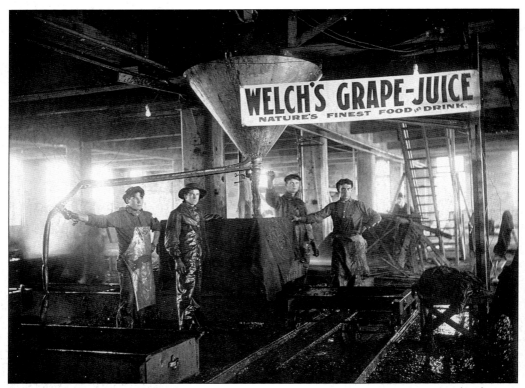

Early Welch's grape juice factory workers oversee the pasteurizing process, turning the doctor's quality grapes into a beverage that quickly gained local popularity. (Courtesy Welch's.)

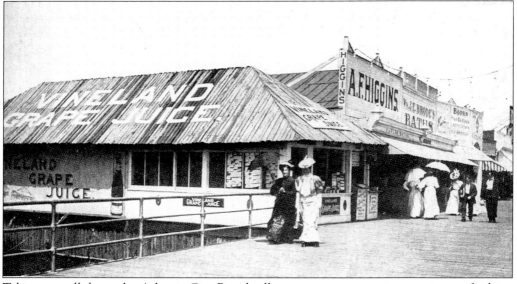

Taking a stroll down the Atlantic City Boardwalk meant an opportunity to enjoy a refreshing glass of Vineland's famed grape juice in the 1920s and 1930s.

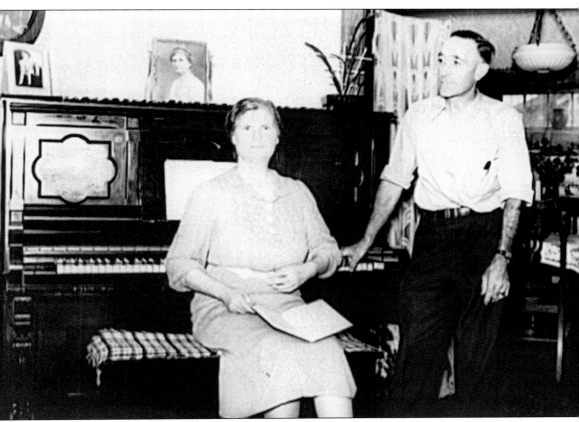

Burlington farmer L. H. Adams poses with his wife in their home in August 1938. Adams was the first farmer in Region I to receive a $5,000 loan under the federal Tenant Purchase Program, which provided low-interest, long-term credit to landless farmers to buy property. Between 1937 and 1947, the program provided financial assistance to 47,000 farmers, close to 70 percent of them located in the southern states. (Courtesy Library of Congress, Prints and Photographs Division.)

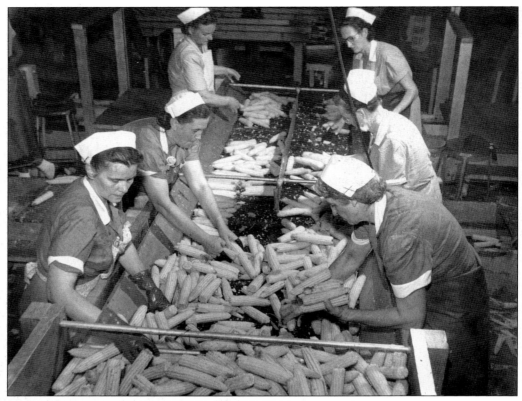

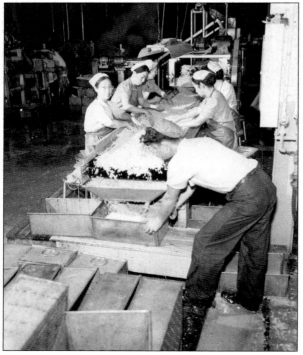

Charles F. Seabrook, son of Seabrook Farms' founder Arthur Seabrook, introduced industrial techniques such as assembly lines (seen here during corn harvesting season) and product research into the business of farming. In the 1930s, *Fortune* magazine dubbed him "the Henry Ford of Agriculture." A farming pioneer from childhood, in 1909, at the age of 14, Charles began developing an overhead irrigation system that simplified Seabrook's growing process at company farmlands in Cumberland, Salem, Atlantic, and Gloucester Counties. (Courtesy Seabrook Farms Educational and Cultural Center.)

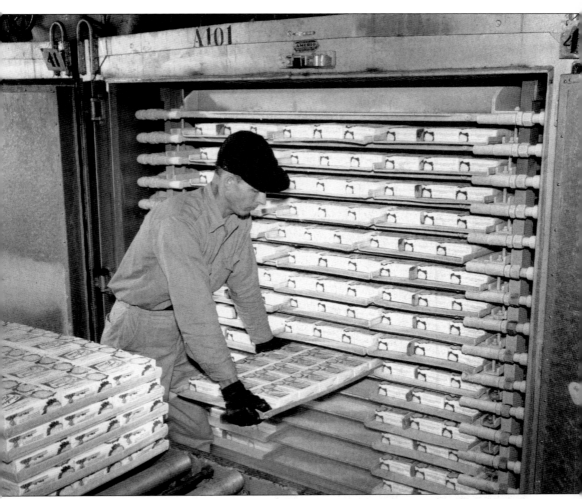

Seabrook Farms began experimenting with frozen foods in 1913, and became the first company to freeze fruits and vegetables for mass consumption after teaming with Birdseye in the 1930s. In this photograph, Seabrook-grown and processed vegetables are loaded for quick freezing using steam-powered ammonia compressors formerly employed to make ice. The company's slogan accurately stated, "We grow our own so we know what's good, and we freeze it right on the spot." At its peak in the 1950s, Seabrook produced 15 percent of the nation's frozen vegetables. (Courtesy Seabrook Farms Educational and Cultural Center.)

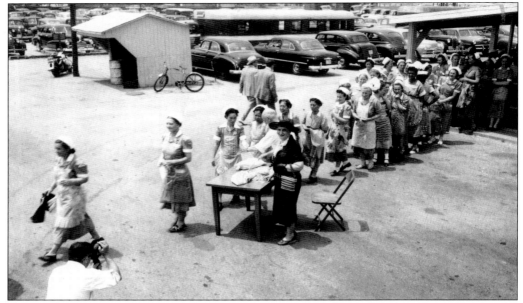

On June 30, 1950, as a publicity stunt to show its economic might, Seabrook Farms paid over 3,000 employees with more than 250,000 silver dollars (nicknamed cartwheels) hauled in by truck from the United States Mint. (Courtesy Seabrook Farms Educational and Cultural Center.)

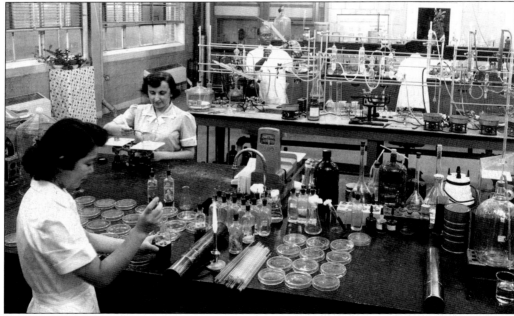

Laboratory workers in Seabrook's quality control department constantly monitored the water treatment system, processing equipment, and final products to ensure consistency. Seabrook's unique farming and processing system left nothing to chance. Company chemists analyzed the soil temperature and mineral and water content to properly fertilize the soil before planting, and the climatology lab determined the best time to plant and harvest crops. (Courtesy Seabrook Farms Educational and Cultural Center.)

Two

THE GOOD EARTH

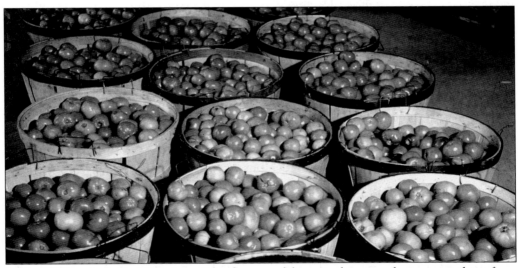

In the 1860s, over half of New Jersey's land was used for agriculture, producing everything from fruits and vegetables to chickens and dairy cows. Over half of the fruit and vegetable farms were located in South Jersey, where the nutrient-rich soil in some locations grew great tomatoes, and the sandy soil in other areas attracted cranberry farmers. (Courtesy Library of Congress, Prints and Photographs Division.)

Fertile soil and favorable weather conditions made New Jersey the perfect spot to grow everything but tropical crops. Since Colonial times, the state has served as the produce supplier for the surrounding regions. This postcard was used by several southern counties to promote their bountiful crops.

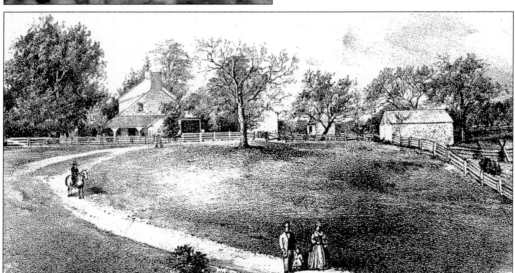

This 1860 sketch of the West Deptford farm known as Greenfield depicts owners William Wade and Sarah Griscom on the property. The farm was established in 1740, and purchased in 1860 by the Griscoms, who continued operating it for eight generations. (Courtesy Gloucester County Historical Society.)

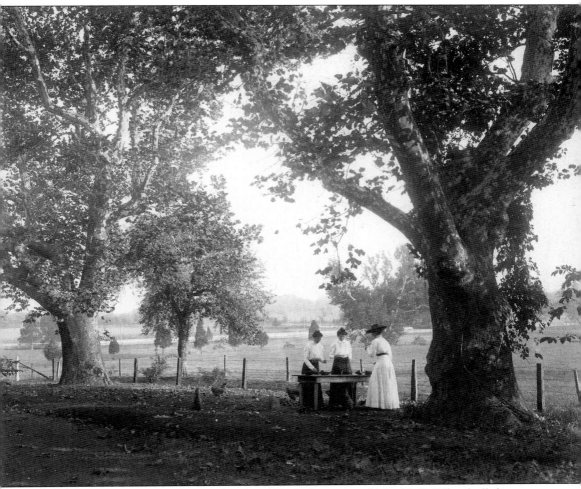

In this 1910 photograph, Lydia C. Griscom, Emily S. Cooper, and Matilda F. Whitehall slice up some just-picked watermelon at Greenfield. The West Deptford property is now the site of the Greenfields Village housing development. (Courtesy Gloucester County Historical Society.)

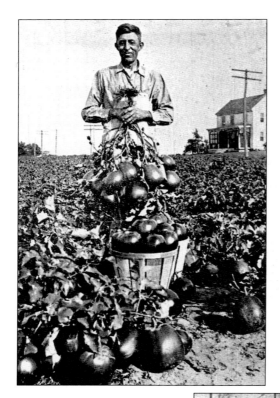

William B. Kille of Swedesboro poses with his prized eggplants around 1915. Kille's farm sold a variety of seeds and tomato, eggplant, pepper, and strawberry plants grown on approximately 15 acres. (Courtesy Gloucester County Historical Society.)

Ruth Kille poses with Paul's Jersey Giant Peppers grown at her family's Swedesboro farm. The giant peppers were named for local farmer Harley Paul, who crossed three different pepper varieties around 1900 to produce these large, red beauties. (Courtesy Gloucester County Historical Society.)

Pleasant Meadows, owned by the Howey (Howe) family, encompassed several hundred acres in Woolwich Township. Owned by Jacob and Elizabeth Howey, the farm's affairs were handled by an overseer while Jacob pursued his career as a surveyor, judge, and New Jersey assemblyman. Over the years, the Howey's children and other relatives built their own homes and a private schoolhouse on the property, among the barns and other outbuildings seen here. The schoolteacher took turns living with various family members as a boarder. (Courtesy Gloucester County Historical Society.)

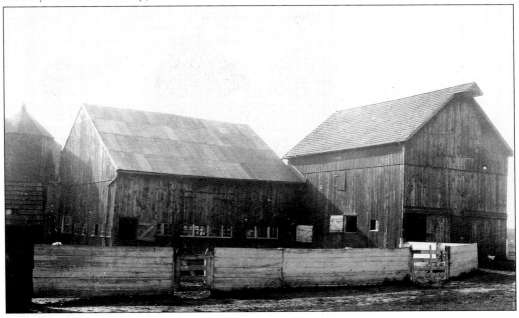

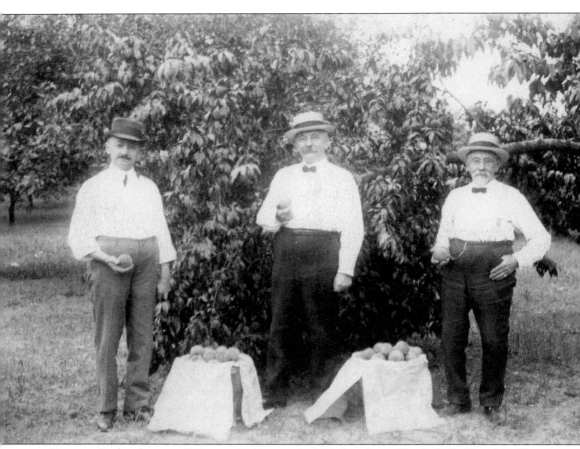

Pomona Orchard owners Solomon H. Stanger Jr. (right) and sons Frank R. (left) and C. Fleming Stanger show off their peach crop around 1910. Pomona Orchards, known for their peaches, apples, and pears, spanned 133 acres on Delsea Drive in Glassboro. (Courtesy Robert Sands Jr.)

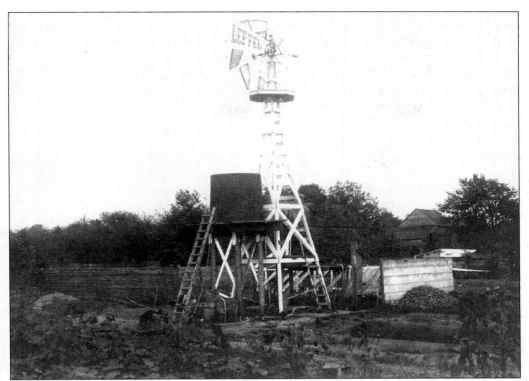

An iron windmill, used as a power source, dominates the landscape at the Brown farm located opposite Eglington Cemetery on Cohawkin Road in Clarksboro. (Courtesy Gloucester County Historical Society.)

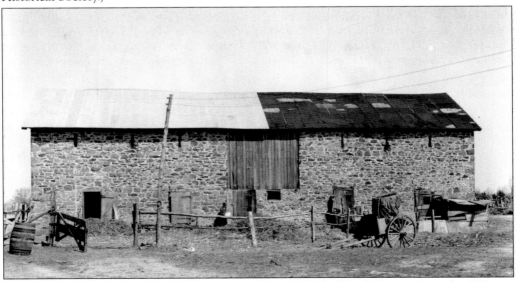

This two-story stone barn was built between 1765 and 1770 by Tench Francis Jr. on his 750-acre farm along the Mantua Creek in Gloucester County. For years, Francis was the agent for the William Penn family. He also served as the first cashier of the Bank of America. (Courtesy Library of Congress, Historic American Buildings Survey.)

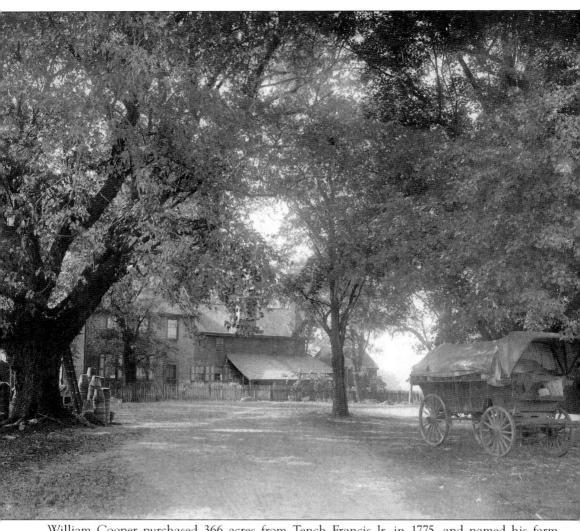

William Cooper purchased 366 acres from Tench Francis Jr. in 1775, and named his farm Cooperfield. Empty produce baskets are stacked beneath a tree at the Gloucester County farm as a wagon, loaded with a portion of the day's harvest, stands ready for the trip to market. (Courtesy Gloucester County Historical Society.)

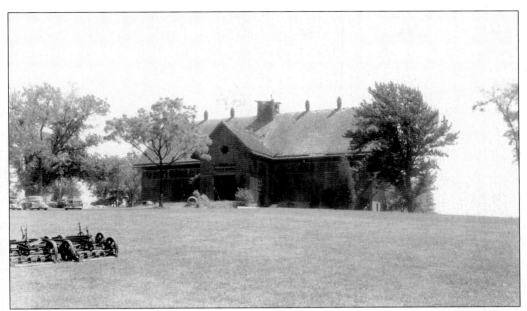

The Alexander Cooper Farm, also known as the Apple Blossom Farm, located at Coffin's Corner, is pictured here in 1956. (Courtesy Camden County Historical Society.)

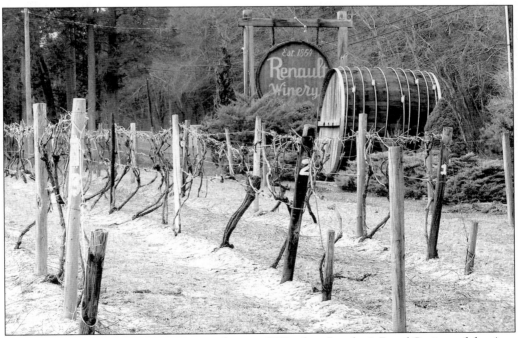

New Jersey has been winning wine awards since 1767, when London's Royal Society of the Arts recognized two local vintners for successfully producing the first bottles of quality wine from colonial grapes. Renault Winery's vineyards date to 1864, making it one of the oldest continually operated wineries in the nation.

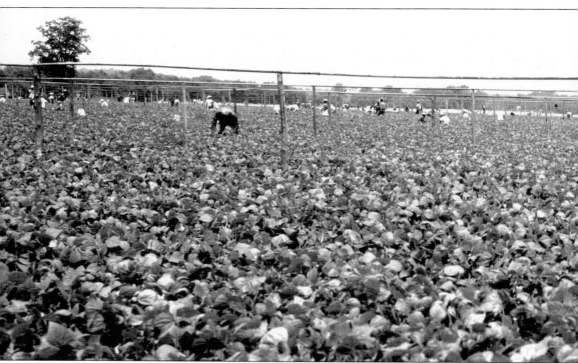

Arthur Seabrook started his Seabrook Farms enterprise by working 61 acres in Deerfield Township in 1893. In this 1942 photograph, migrant workers harvest green beans on Seabrook's sprawling farmlands. By the close of World War II, Seabrook Farms employed over 5,000 workers and had become the largest vegetable farm in the world, producing nearly two dozen varieties of fruits and vegetables. (Courtesy Library of Congress, Prints and Photographs Division.)

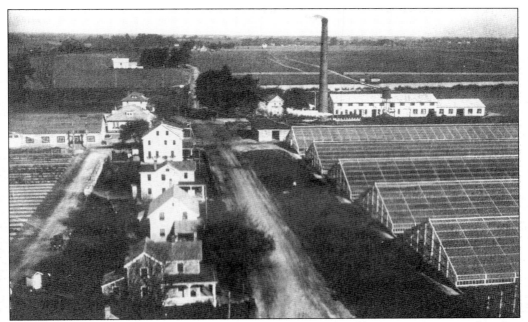

Seabrook Farms' greenhouses and nurseries in Bridgeton, pictured here in 1919, nurtured quality seedlings for the enterprise's fields in Salem, Cumberland, Atlantic, and Gloucester Counties. (Courtesy Seabrook Farms Educational and Cultural Center.)

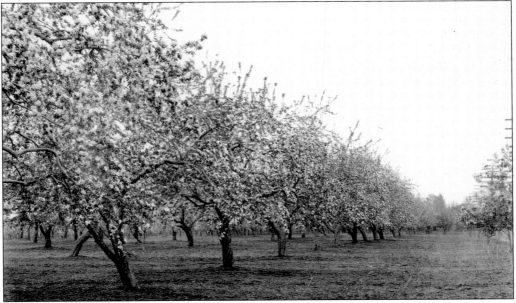

Peaches were a major crop in Burlington, Cumberland, Camden, Atlantic, and Gloucester Counties. In 1908, a peach orchard was established on the grounds of the training school at Vineland to conduct a variety of experiments. Overseen by the New Jersey Agricultural College at New Brunswick, the orchard imported trees from around the world for crossbreeding and developed the famous Golden Jubilee. This undated photograph shows a peach orchard in bloom in Salem County. (Courtesy Camden County Historical Society.)

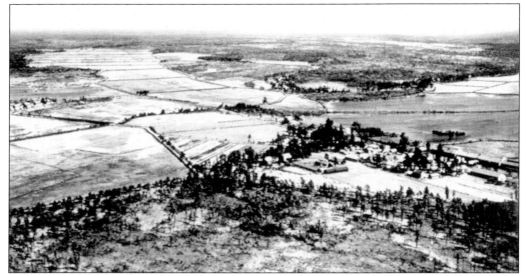

This aerial view of Whitesbog, taken around 1930, shows the extent of the Burlington County cranberry enterprise, which encompassed 3,000 acres and included a laborer's village and company store. Whitesbog was one of many cranberry bogs operating in Burlington and Atlantic Counties. (Courtesy New Jersey Conservation Foundation.)

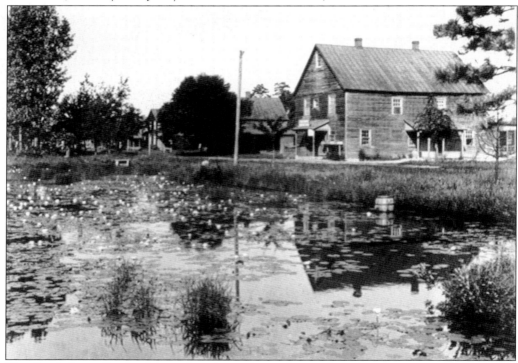

The South Jersey Pinelands's sandy soil was the perfect medium for growing cranberries, but a substantial water supply was also essential since the crops occasionally needed to be flooded. The pond at Whitesbog, photographed here in 1910, was a central part of the cranberry operation. (Courtesy New Jersey Conservation Foundation.)

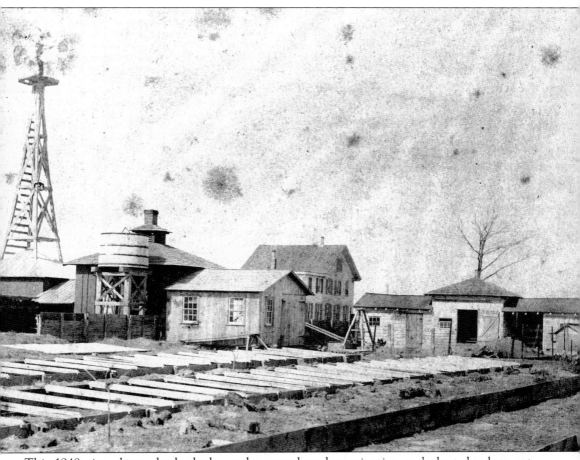

This 1948 view shows the hotbeds, used to speed seed germination and plant development, on the farm of Henry David Chew and his father John David Chew in Glassboro. (Courtesy Gloucester County Historical Society.)

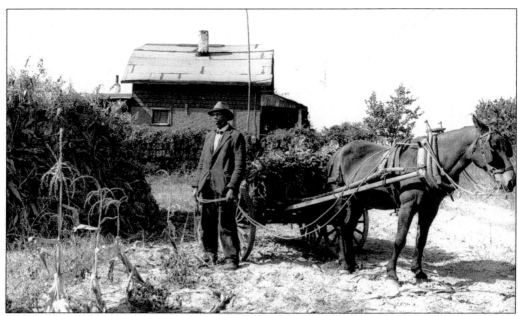

Throughout its history, South Jersey farming ranged from small garden-style farms to massive corporate operations. The small farm above was tended by this man, living in Glassboro's Eighty Acres housing project. A government-funded project, Eighty Acres was developed to provide housing for corporate farm laborers. In contrast, a small portion of Seabrook Farms' approximate 1,900 acres can be seen in the image below. In addition to its corporate-owned farmland, in its heyday Seabrook also contracted with over 700 regional farmers for produce. (Above, courtesy Library of Congress, Prints and Photographs Division.)

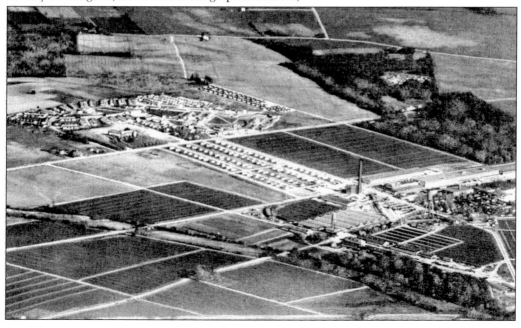

This photograph, taken between 1885 and 1900, shows a portion of the farmland and several outbuildings of the Savich Farm in Evesham Township. The farm was originally owned by Benjamin and Lydia Evans Cooper. (Courtesy Camden County Historical Society.)

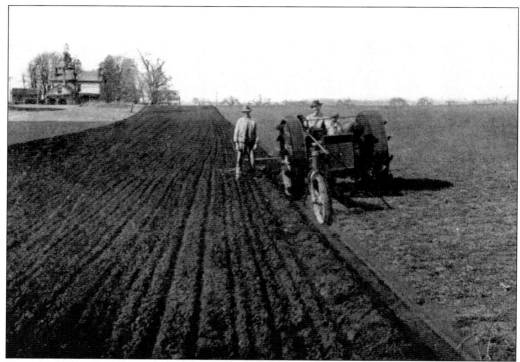

Over the years, the lay of South Jersey's farmland was adapted to accommodate tractors, which resulted in easier soil preparation. (Courtesy Cumberland County Historical Society.)

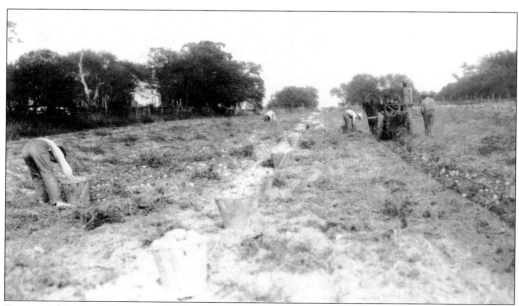

Potato picking is underway in 1912 at the Brewer Farm on Mount Ephraim-Blackwood Turnpike. (Courtesy Camden County Historical Society.)

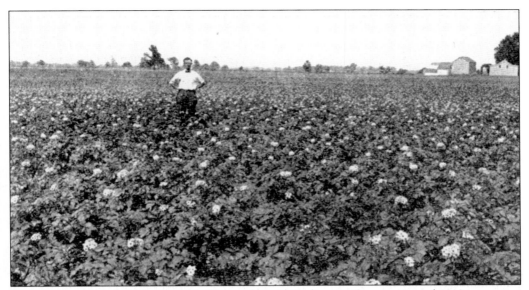

The potato crop is in bloom on this 60-acre farm in Burlington County around 1910.

Although the land was originally viewed as being too poor in quality to produce much, Charles Landis's successful venture in selling plots for farming proved that opinion wrong, and more and more real estate developers began marketing the area as the perfect place to raise healthy crops and families. (Courtesy Vineland Historical Society.)

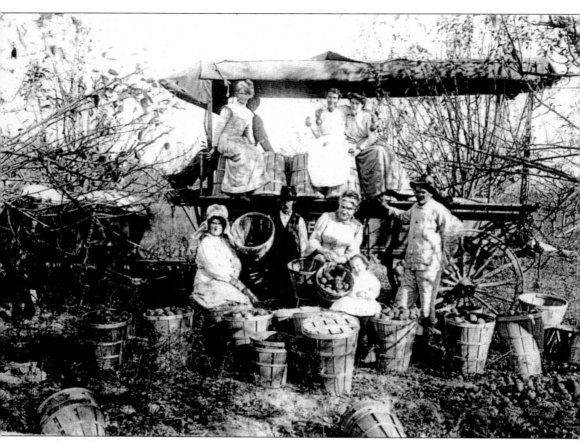

The Hall family shows off the fruits of their labor from their Vineland farm in this undated photograph. (Courtesy Vineland Historical Society.)

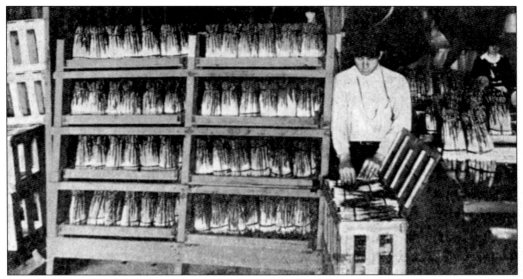

The lighter soil found in certain sections of South Jersey produced quality asparagus. Harvesting and packing this crop has always been labor-intensive, with each stalk having to be individually hand cut, sorted, and bundle wrapped. Above, stalks are bundled and stacked for shipping. Below, Brookside Farms' pedigreed asparagus is inspected before being shipped out for sale. (Courtesy Cumberland County Historical Society.)

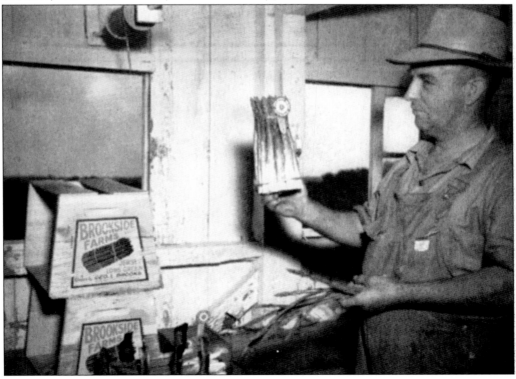

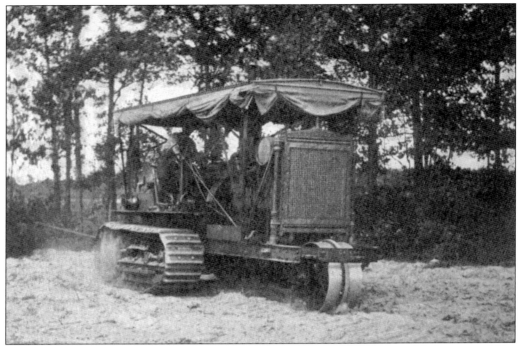

No matter how good the soil, usable farmland occasionally had to be cleared before it could be planted. This Holt Caterpillar tractor was capable of removing stumps as well as trees from the land. (Courtesy Camden County Historical Society.)

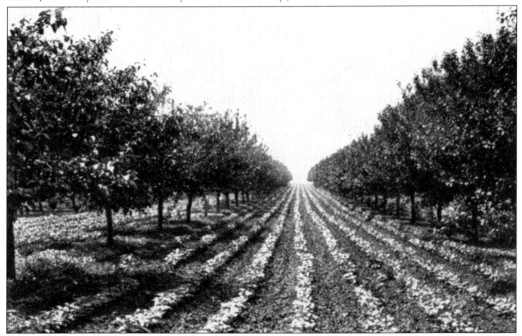

Making the best use of the available land, this Cumberland County farm combined vegetables and fruit trees to guarantee a varied crop. (Courtesy Cumberland County Historical Society.)

With proper care and a lot of patience, much of South Jersey's soil was certain to yield considerable crops. But before heavy machinery, farmers like this one spent their days hand plowing, planting, tending, and harvesting their crops. (Courtesy Library of Congress, Prints and Photographs Division.)

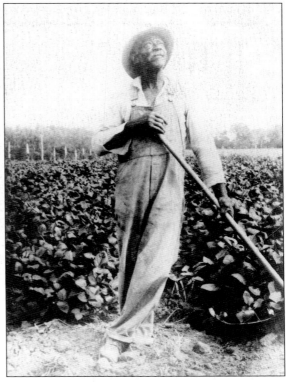

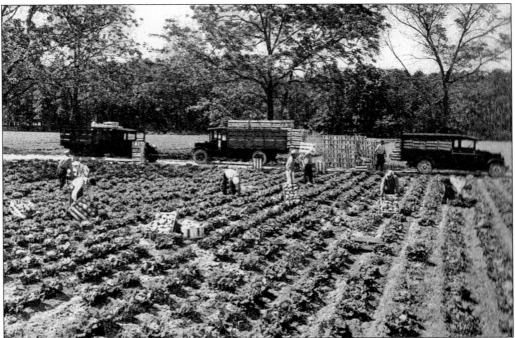

The Dennis Farm in Atlantic County supplied fresh produce for the renowned Dennis Hotel in Atlantic City. It was one of countless farms scattered throughout the county.

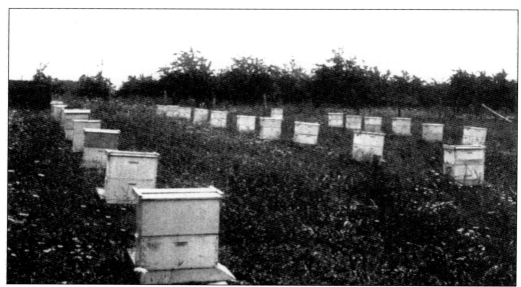

Some farmers also raised bees, like the ones housed in these boxes, to help ensure a strong fruit yield in their orchards. (Courtesy Cumberland County Historical Society.)

With the development of more scientific farming strategies, farmers began seeking the assistance of county agents for soil testing, planting recommendations, and pest control guidance. In this photograph, a Cumberland County agent conducts a soil test for a local farmer. (Courtesy Cumberland County Historical Society.)

Three

MAN AND MACHINE

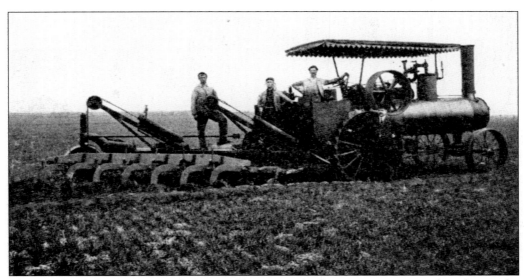

This newfangled steam-powered plow could create eight furrows at once, greatly reducing the soil preparation time for South Jersey farmers lucky enough to have access to one in 1912, when this photograph was taken.

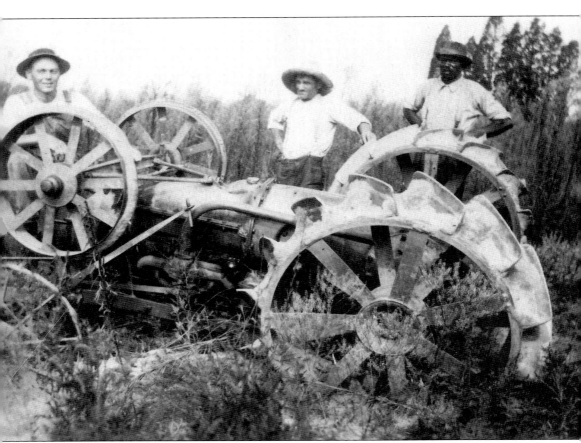

Charles S. "Doc" Densten (center) contemplates the best way to right his overturned Fordham tractor in 1926 at the Old Herb Richards Farm on Cohawkin Road in East Greenwich. Known as killers by the farmers of the day, the Fordham model was prone to flip when the plow hit a large rock or tree root. Prepared to help Densten are Charles A. "Buck" Hewett (left) and Al Thomas. (Courtesy Gloucester County Historical Society.)

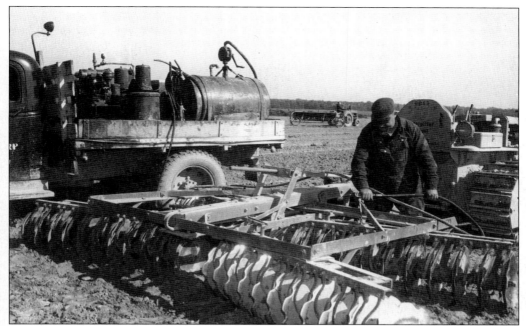

While Seabrook Farms' innovations included scientifically scheduled planting and harvesting to yield the strongest, most productive crops, even this agricultural innovator followed certain farming basics. One of the first steps in the farming process involved setting up the harrow to smooth out the company's more than 20,000 acres in Cumberland, Salem, Atlantic, and Gloucester Counties. (Courtesy Seabrook Farms Educational and Cultural Center.)

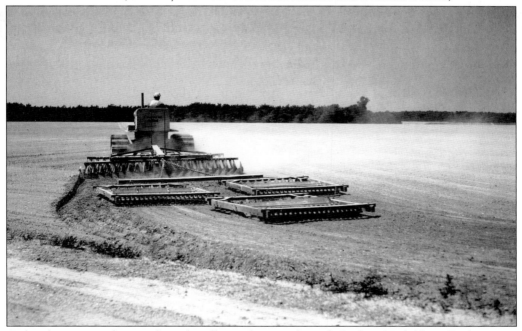

A diesel tractor makes quick work pulling a harrow through Seabrook's fields in Bridgeton in 1942. (Courtesy Library of Congress, Prints and Photographs Division.)

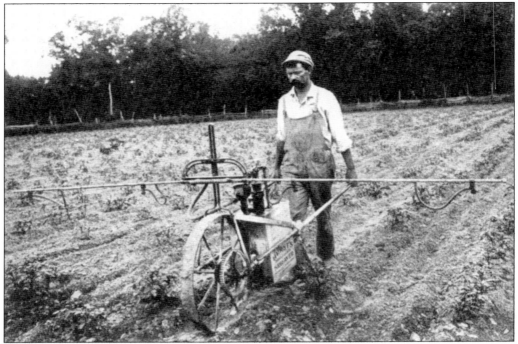

A Burlington County farmer tends to his young potato plants with an early fertilizing machine equipped to reach a broad area around 1910.

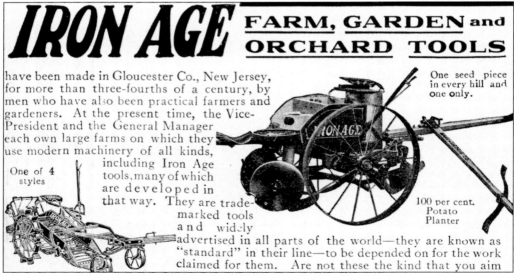

IRON AGE
FARM, GARDEN and ORCHARD TOOLS

have been made in Gloucester Co., New Jersey, for more than three-fourths of a century, by men who have also been practical farmers and gardeners. At the present time, the Vice-President and the General Manager each own large farms on which they use modern machinery of all kinds, including Iron Age tools, many of which are developed in that way. They are trademarked tools and widely advertised in all parts of the world—they are known as "standard" in their line—to be depended on for the work claimed for them. Are not these the kind that you aim

One of 4 styles

One seed piece in every hill and one only.

100 per cent. Potato Planter

Bateman Manufacturing Company was well-known in the area for their Iron Age brand of farm, orchard, and garden equipment, including sprayers, hoes, cultivators, and hay rakes. Pictured in this advertisement are two of the Grenloch-based company's potato planters.

A migrant worker stacks sacks of insecticide in preparation for the spring battle against bugs at Seabrook Farms. (Courtesy Seabrook Farms Educational and Cultural Center.)

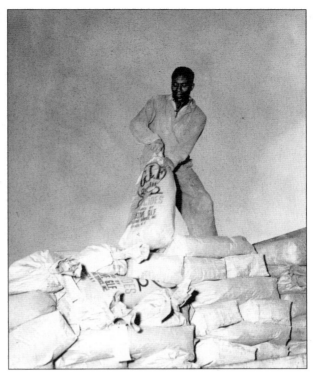

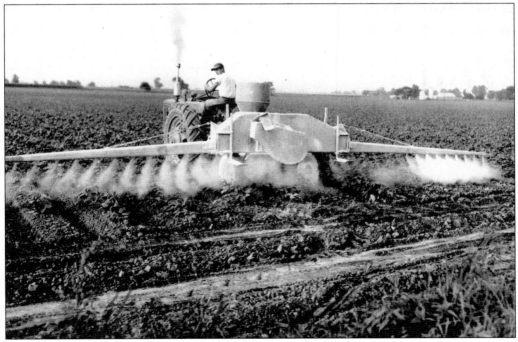

Fertilizer is spread across Seabrook's sprawling crops based on careful laboratory testing to determine the mineral and moisture content of the soil. (Courtesy Seabrook Farms Educational and Cultural Center.)

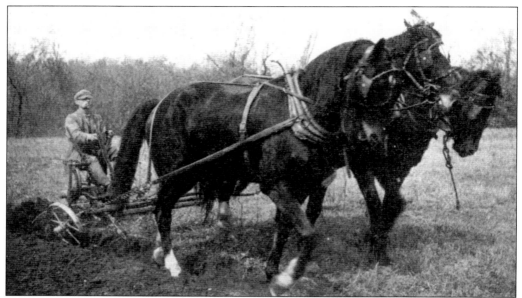

Farmers of reasonably-sized plots who used horse-drawn equipment, like this Burlington County farmer, needed to maintain at least two teams of strong workhorses to work the land. (Courtesy Camden County Historical Society.)

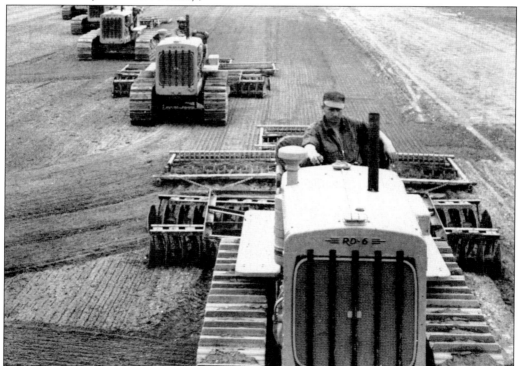

Farming operations of the magnitude of Seabrook Farms maintained a large fleet of tractors. In this photograph, the fleet rolls out to plow the fields in Cumberland County. (Courtesy Cumberland County Historical Society.)

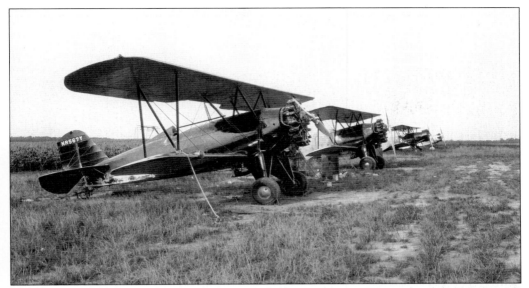

Crop-dusting planes stand ready for takeoff in Bridgeton in 1942. Dusting squads like this one followed the growing season up and down the East Coast, hired by farmers to disburse pesticides. Planes rehabbed as dusters were usually two-seaters, with the front seat replaced with a hopper containing insect spray. Pilots often suffered fatalities during runs, flying low to avoid chemical drift and hitting fence posts and telephone or electrical lines. (Courtesy Library of Congress, Prints and Photographs Division.)

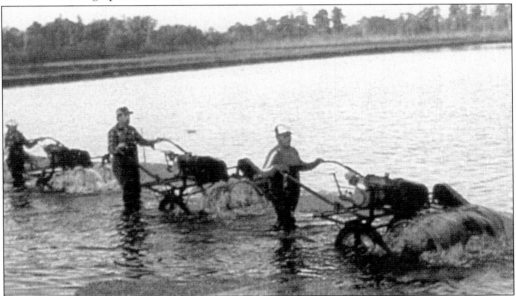

Late in the cranberry-picking season, bogs were routinely flooded and then agitated. The water movement caused the cranberries that had fallen on the ground during hand harvesting to float to the surface, where they could be collected using special scoops. Since the 1960s, most New Jersey cranberries are harvested this way, with mechanical beaters knocking the berries into the water, where they are corralled and collected with rakes. (Courtesy Library of Congress, Prints and Photographs Division.)

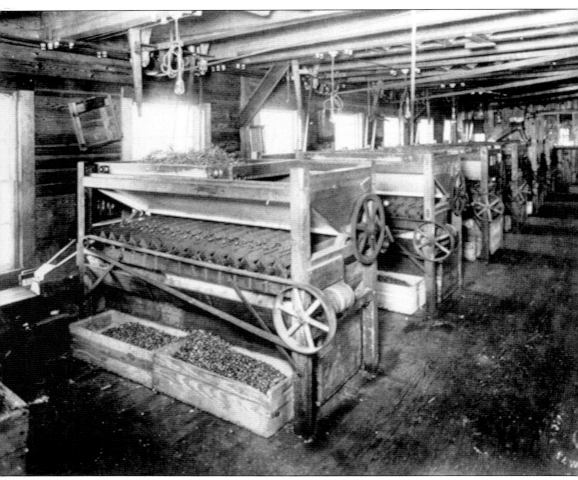

Once cranberries were delivered to the sorting house at Whitesbog, the crop made its way to this room, where the vines and leaves (visible in the top bins) were easily separated from the berries by these automated machines. (Courtesy New Jersey Conservation Foundation.)

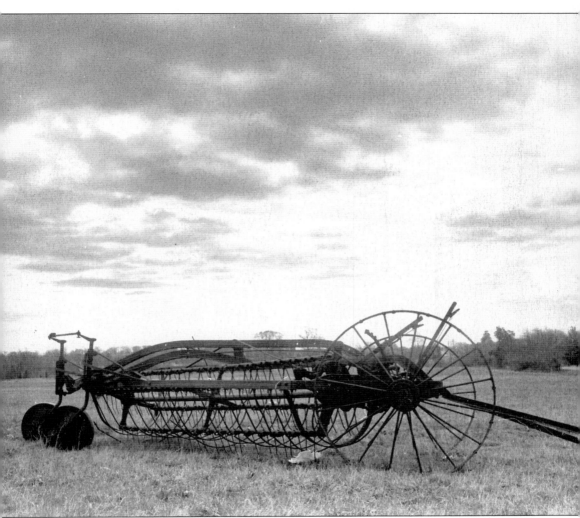

An old hay rake rests under the cloud-filled sky on a farm along Parkville Road in West Deptford. In the days when hay was transported to the barn loose, the rake, which gathered the hay in piles and left it for collection with a pitchfork, was a laborsaving advancement over raking it into piles by hand as it was mowed. (Courtesy Gloucester County Historical Society.)

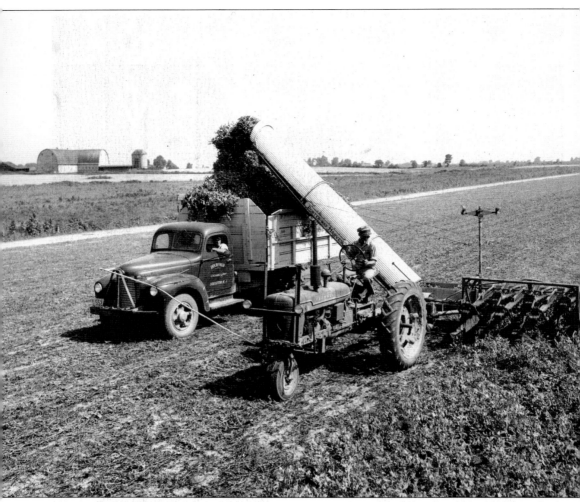

During Seabrook's harvest season, pea plants were gathered and deposited into trucks, which delivered them to mechanized viners where the peas were extracted. The remaining vines and leaves were chopped up and returned to the fields as fertilizer. (Courtesy Seabrook Farms Educational and Cultural Center.)

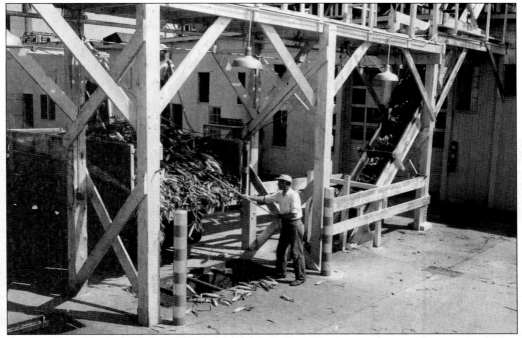

A load of corn is dumped into Seabrook's husking machine in 1952, after specially designed harvesters marched through the field stripping ears from the stalks and dropping the stalks to the ground. (Courtesy Seabrook Farms Educational and Cultural Center.)

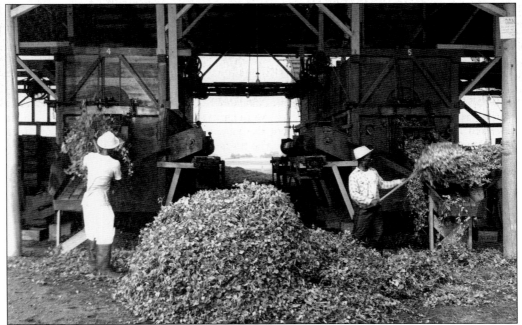

Seabrook Farms migrant workers shovel harvested pea plants into the automated viners. In some cases, less than an hour elapsed between the time a vegetable was harvested and the time it was frozen. (Courtesy Seabrook Farms Educational and Cultural Center.)

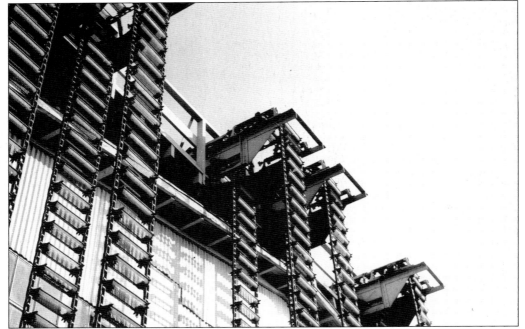

Once separated, raw peas and lima beans were transported via these towering elevators to the third floor of Seabrook's massive 23-acre factory for processing. A January 1955 *Life* magazine article referred to the Seabrook operation as "the biggest vegetable factory on earth." (Courtesy Seabrook Farms Educational and Cultural Center.)

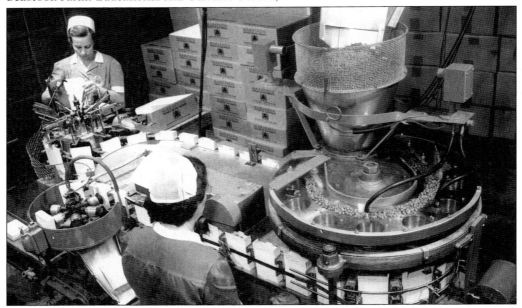

Approximately 600 cartons were filled every minute on the marathon pea line at Seabrook Farms around 1950. Once filled, underweight cartons were booted from the line on the left, and good cartons made their way to the wrapping machines under Birdseye, Snow Crop, and other labels. (Courtesy Seabrook Farms Educational and Cultural Center.)

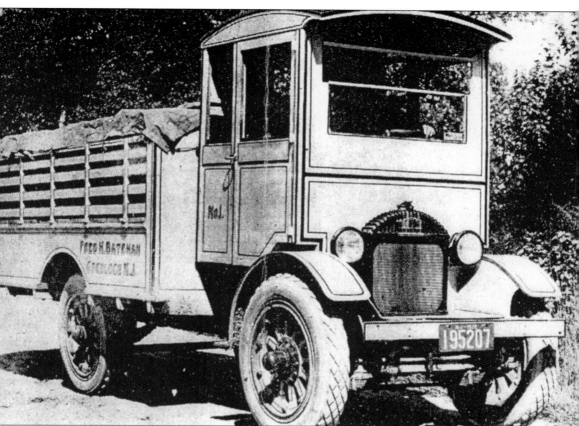

The one-and-only Frontmobile truck, pictured here in a potato field in 1920, was developed by the Bateman Manufacturing Company and built by Camden Motor Corporation in Camden. It employed the newly invented front-wheel drive system and could travel through freshly-plowed and harrowed fields. Although only one of these trucks was ever constructed by the successful Grenloch Terrace company, Bateman was well-known for its farm and garden machinery and 20-plus acres of experimental farmland.

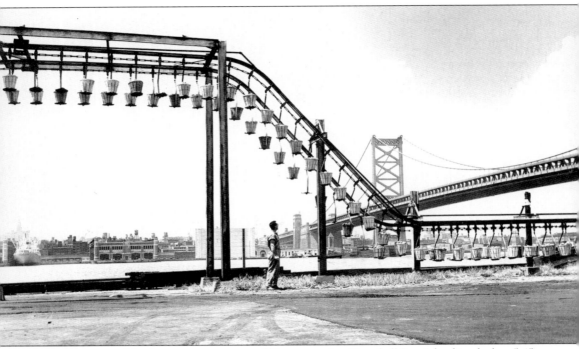

The contents of the first tomato wagon would be accepted at Campbell Soup's loading dock at 5:45 a.m. each morning and, after an initial quality inspection to determine the farmer's pay scale, would travel on this lift into the factory. Once inside, the produce would undergo a series of washings before facing a more thorough inspection and processing. (Courtesy Campbell Soup Company.)

Four

EVERY MAN, WOMAN, AND CHILD

Working the land was always a family affair, with farmers having large families to help work the fields and employing large migrant and immigrant families to pitch in at harvest time. The largest reported New Jersey farm family was noted in Flemington in the 1790s, when one woman claimed to have 17 children, 130 grandchildren, 100 great-grandchildren, and 1 great-great-grandchild at the time of her death. (Courtesy Library of Congress, Prints and Photographs Division.)

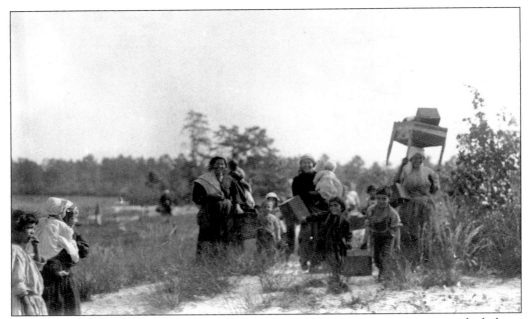

Families working at harvest time moved from section to section as an area was picked clean, carrying the provisions they needed for a day in the field with them. (Courtesy Library of Congress, Prints and Photographs Collection.)

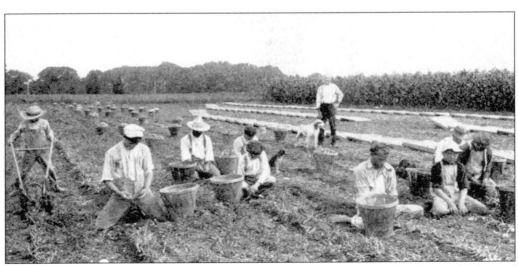

Onion pickers in Burlington County work the fields on their knees, under the watchful eye of the farm owner and his dog. (Courtesy Gloucester County Historical Society.)

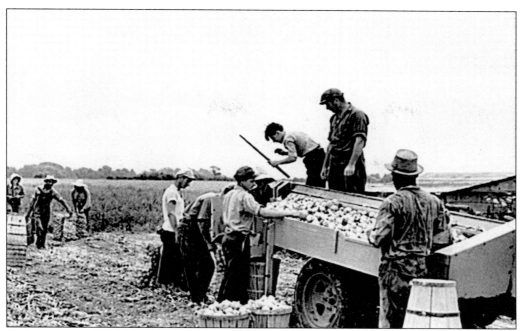

Onion-picking migrant workers haul bushel baskets of onions to the portable grader for weighing in Cedarville. (Courtesy Library of Congress, Prints and Photographs Division.)

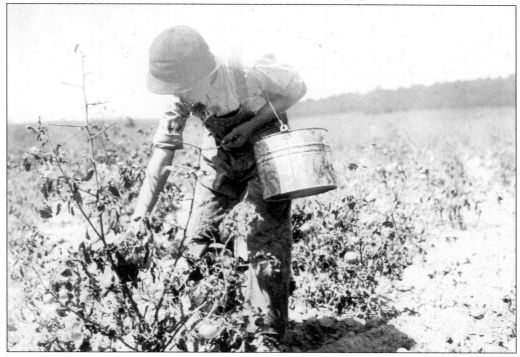

A young tomato picker selects the ripe tomatoes from a plant. The tomato-picking season in South Jersey ran from July to October, the longest season of any crop in the state. (Courtesy Library of Congress, Prints and Photographs Division.)

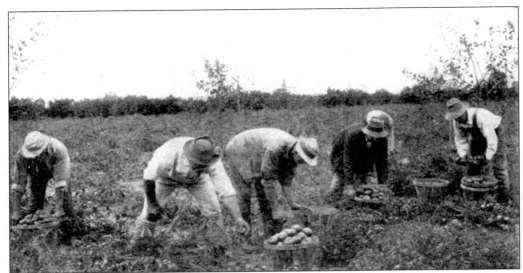

In the early part of the 20th century, most farmers could expect to produce between four and five tons of tomatoes per acre. Once scientific advancements in seed selection, fertilization, irrigation, and pest control took hold, yields rose to 8 to 12 tons per acre. (Courtesy Library of Congress, Prints and Photographs Division.)

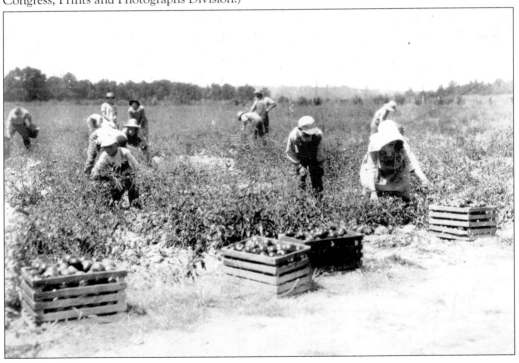

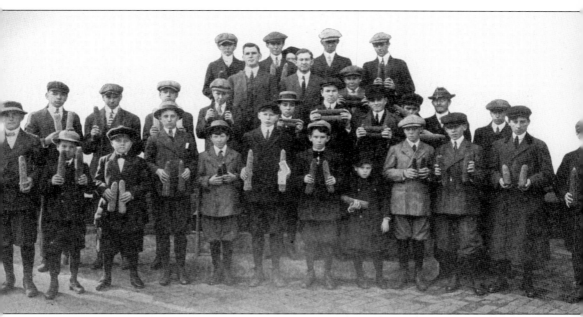

The winners of the 1912 Burlington County Boys' Corn-Growing Contest proudly display their entries in the annual farming competition. (Courtesy Camden County Historical Society.)

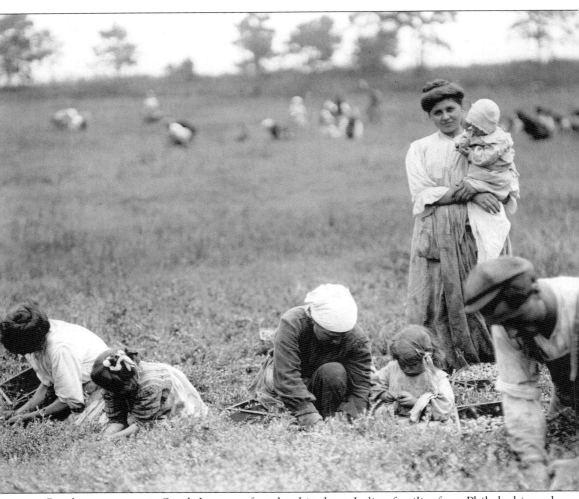

Cranberry growers in South Jersey preferred to hire large Italian families from Philadephia and Delaware to harvest their crops each year, starting the children off as young as two. Included in the Frigineto family of Philadelphia were Frances, three, and Marie, five. An infant sister looks on from her mother's arms, and may very well have been ready to join with the rest of the family to crawl on their hands and knees across the muddy bog the following season. (Courtesy Library of Congress, Prints and Photographs Division.)

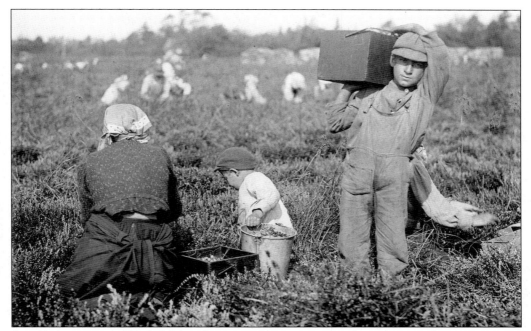

Sam Frohue, nine, of Philadelphia, began working as a seasonal cranberry picker at age seven. The harvest season extended well into October, resulting in children missing a considerable amount of time from school, which may have explained Sam's inability to spell his name for the photographer. Behind him in this 1910 photograph taken at Theodore Budd's bog near Pemberton is Jim Waldine of Carpenter Street in Philadelphia, also a two-year veteran at the age of six. (Courtesy Library of Congress, Prints and Photographs Division.)

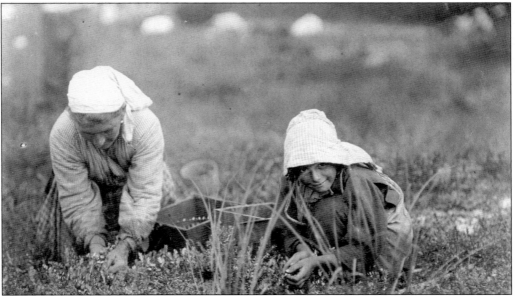

Millie Cornaro of Philadelphia sneaks a smile for the photographer at Whitesbog in Burlington County in 1910. At the time this photograph was taken, Millie, 10, was already a six-year veteran cranberry picker. (Courtesy Library of Congress, Prints and Photographs Division.)

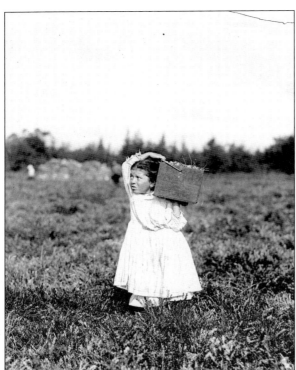

Little Jennie Camillo, five, carrying a 15-pound load of cranberries, begins the long trek to the bushelman for weighing at Theodore Budd's bog in Turkeytown near Pemberton. Her look of distress in this 1910 photograph is the result of her father's impatience with her for stopping to pose for the photographer. Pickers were paid based on the quantity and quality of their harvest. (Courtesy Library of Congress, Prints and Photographs Division.)

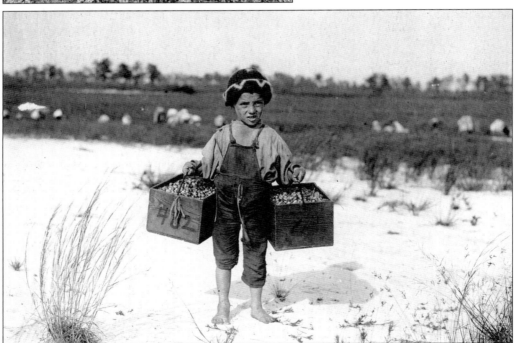

Salvin Nocito, five, heads to the bushelman laden down with two pecks of cranberries, each weighing 15 pounds. The Nocito family was one of many hired at Whitesbog in Browns Mills in the fall of 1910. (Courtesy Library of Congress, Prints and Photographs Division.)

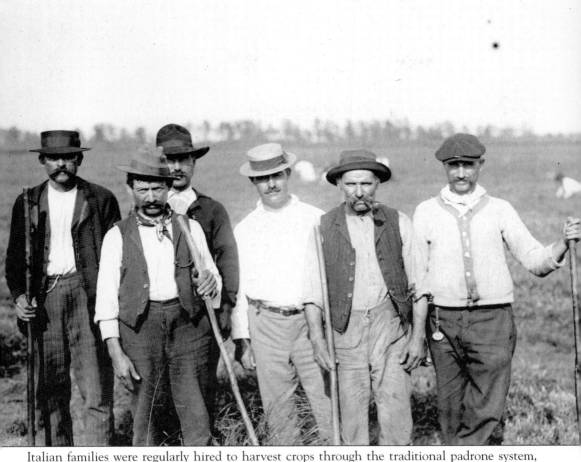

Italian families were regularly hired to harvest crops through the traditional padrone system, where men like these supplied and supervised the laborers and often took a substantial portion of their pay in return. Committed to coaxing the most out of their charges, padrones rarely hesitated to use whatever means necessary to verbally or physically get their point across. Pictured here are six padrones in Browns Mills. Gus Denato (fourth from the left) was the operation's chief padrone when this photograph was taken in 1910. (Courtesy Library of Congress, Prints and Photographs Division.)

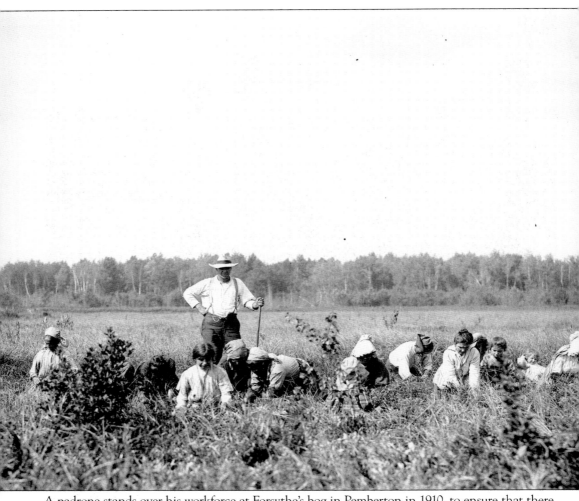

A padrone stands over his workforce at Forsythe's bog in Pemberton in 1910, to ensure that there are no slackers in the group. Each padrone was assigned to a different section of the bog, worked by between 30 and 60 pickers. Their responsibilities included making sure the vines were stripped clean as quickly as possible. Unless carefully supervised, as much as 25 percent of the crop could be left on the vine by pickers. (Courtesy Library of Congress, Prints and Photographs Division.)

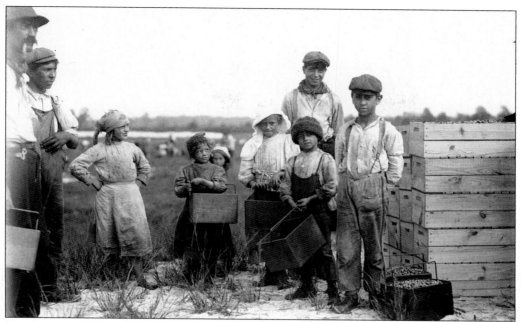

Cranberry pickers gather at the checking station at Whitesbog in September 1910. Pickers worked hard for their money and were paid based on the quality and quantity of the berries they picked. Once a box was inspected at the checking station, the picker received a ticket representing a certain monetary amount, which was redeemable for cash or goods. (Courtesy Library of Congress, Prints and Photographs Division.)

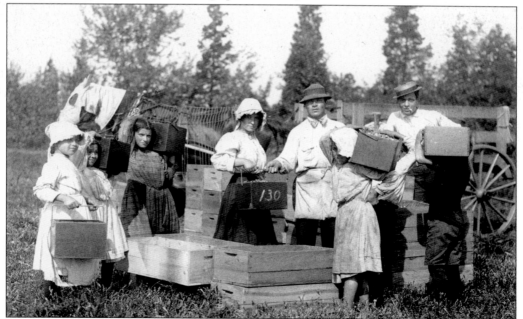

The bushelman at the checking station at Theodore Budd's bog near Pemberton received peck boxes containing 10 quarts instead of the usual 8 quarts from these cranberry pickers in September 1910. (Courtesy Library of Congress, Prints and Photographs Division.)

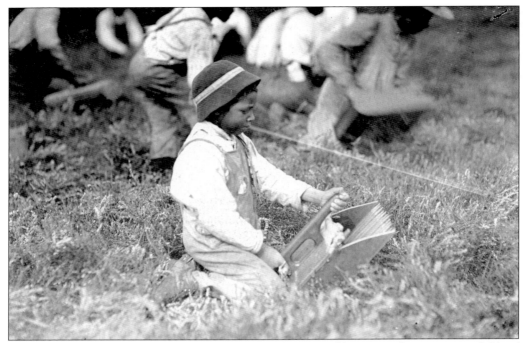

Bog workers use heavy steel cranberry scoops to harvest older vines that are expendable if damaged by the rough treatment of the scoops' claws. (Courtesy Library of Congress, Prints and Photographs Division.)

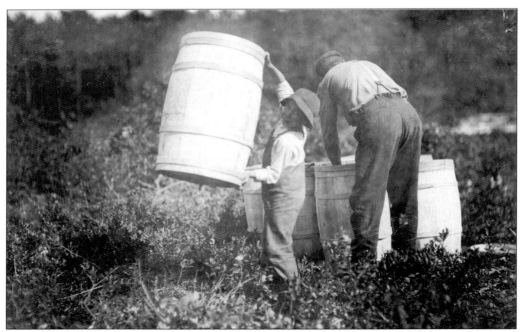

A young bog worker sets out another barrel to be filled by cranberry pickers wielding cranberry scoops. (Courtesy Library of Congress, Prints and Photographs Division.)

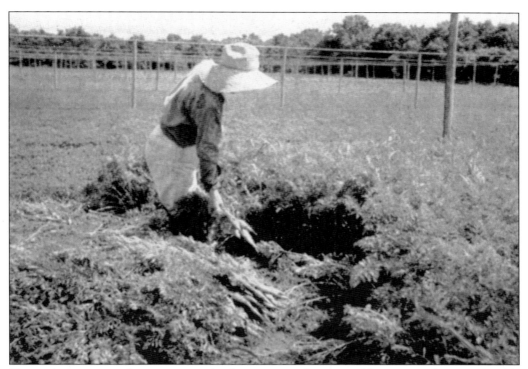

Harvesting carrots takes more muscle than many other vegetables, as can be seen in this photograph of a Cumberland County farm worker pulling carrots in the field. (Courtesy Cumberland County Historical Society.)

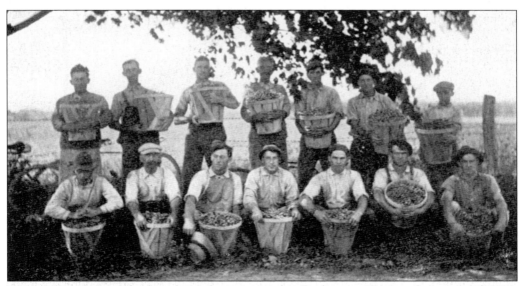

Fruit pickers pose with their latest harvest on this Burlington County farm around 1912. (Courtesy Camden County Historical Society.)

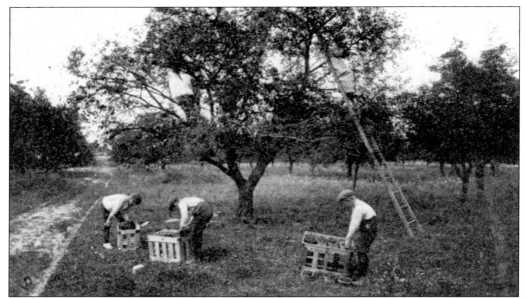

A fear of heights was not an option for cherry pickers on this Burlington County orchard, where steep ladders were the only way to reach the majority of the crop on older, taller trees. (Courtesy Camden County Historical Society.)

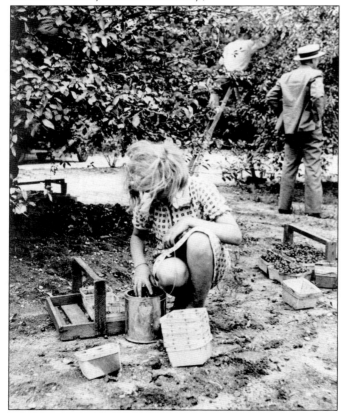

Cherry pickers labor under the watchful eye of an orchard overseer near Millville in June 1936. (Courtesy Library of Congress, Prints and Photographs Division.)

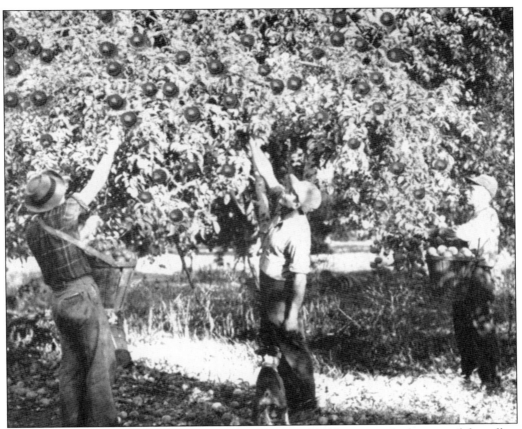

Apple pickers, baskets hanging from their shoulders, used ladders to reach the tops of the tallest trees in a South Jersey orchard around 1930. (Courtesy Cumberland County Historical Society.)

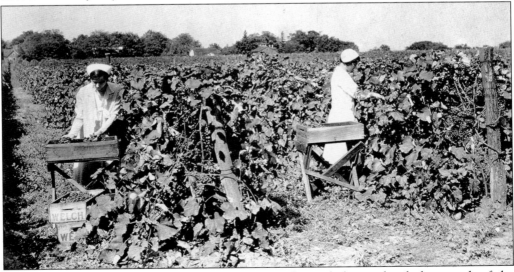

Workers select concord grapes ready for harvest in this early but undated photograph of the Vineland vineyards of Dr. Thomas B. Welch. (Courtesy Welch's.)

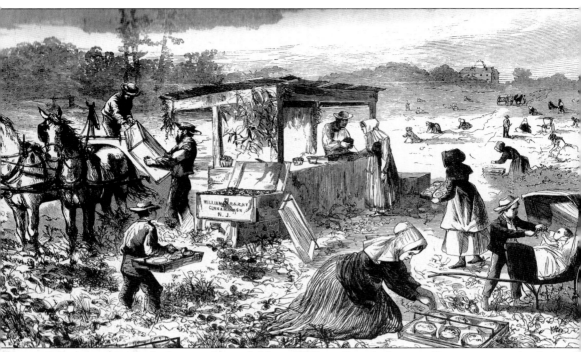

Entire families work the strawberry fields at William Parry's farm in Cinnaminson. As this illustration published in *Harper's Weekly* in 1869 shows, even infants took to the fields at harvest time.

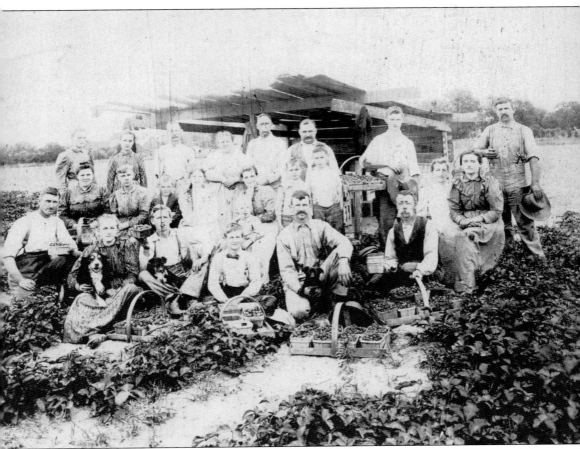

Posing in a strawberry patch at the Steward Farm in Garrison Township around 1895 from left to right are (first row) Edward Batten, Ida Steward Batten, Robert Headley, Albert "Cookie" Allen, Oscar Carter, and E. Schoch; (second row) Lizzie Jenkins Carter, Flo Orems, William Gooden Jr., Augusta Schoch, Annio Schoch, Reeves Schoch, Everett Hook, William Hood, Sara Schoch, and Linda Gooden Messick; (third row) George Batten, Carrie Batten, William Gooden Sr., Haddie Steward, Parker Steward, William Hood, Oscar Owen, and William Jenkins. (Courtesy Gloucester County Historical Society.)

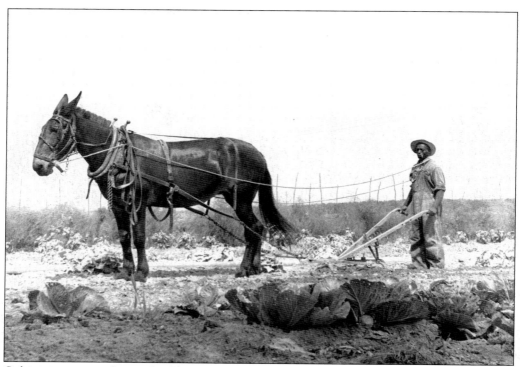

Cultivating required considerable manpower on most farms in the 1930s. In the photograph above, a cabbage field is cultivated, while below field laborers tend to the spinach crop. (Courtesy Seabrook Farms Educational and Cultural Center.)

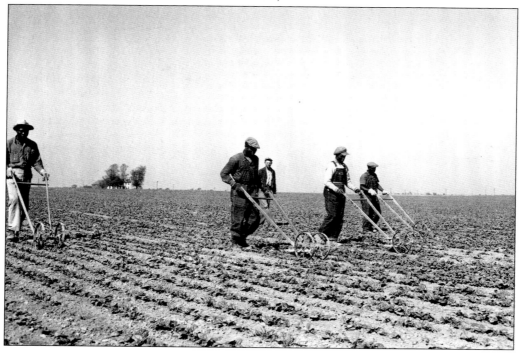

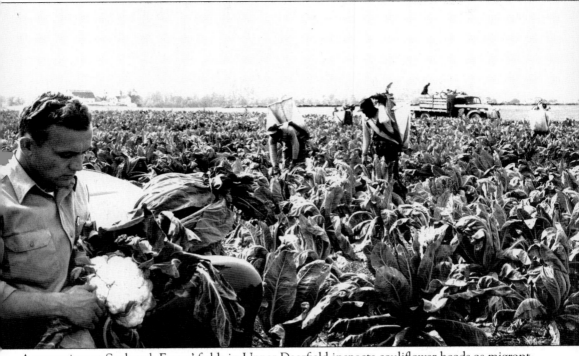

A supervisor at Seabrook Farms' fields in Upper Deerfield inspects cauliflower heads as migrant workers hand pick the crop. (Courtesy Seabrook Farms Educational and Cultural Center.)

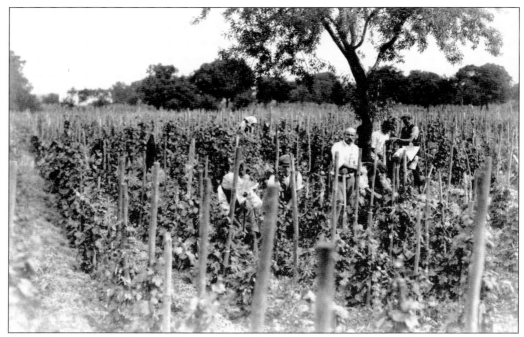

Harvesting grapes in Vineland, known for its bountiful vineyards, was a time-consuming task that required a gentle touch. (Courtesy Vineland Historical Society.)

Five

BEYOND THE FIELDS

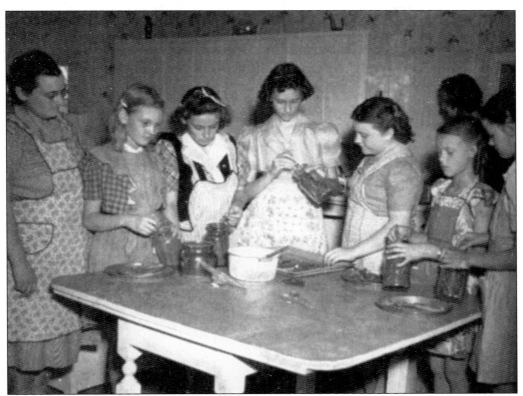

Members of the 4-H Canning Club in Cumberland County gather around the demonstration table to get a good look at the latest canning procedure. Every South Jersey county had active 4-H clubs at one time, providing opportunities for children and teens to learn about a variety of agricultural activities. (Courtesy Cumberland County Historical Society.)

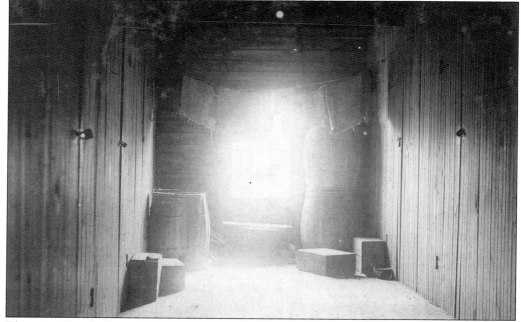

The upper floor hallway of a large 12-room migrant workers' barracks in 1910 illustrates the stark nature of their housing. Padlocks keep each family's possessions safe within their rooms while they are in the fields during the day, and hand-rinsed towels hang drying in front of the one hall window. (Courtesy Library of Congress, Prints and Photographs Division.)

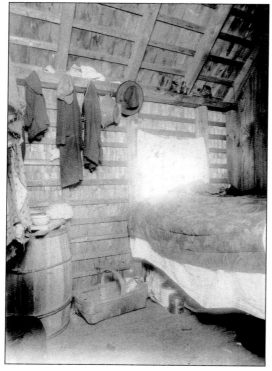

Home to a husband and wife, as well as their four sons, this shanty included two tiny bedrooms, which were used for sleeping, eating (as can be seen by the food stored by the bed), and to air out clothes when they were not being worn. (Courtesy Library of Congress, Prints and Photographs Division.)

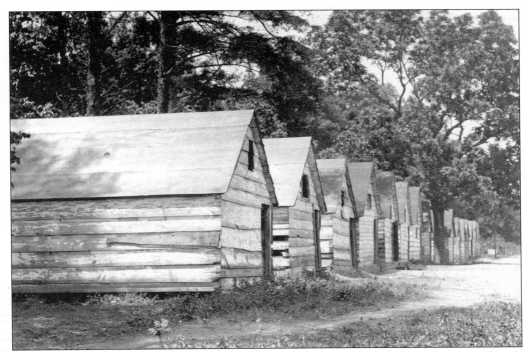

Migrant worker shacks line a dirt road in an unidentified section of Atlantic County (above), and a multi-residence migrant barracks stands along Route 410, Cedarville Road, in Cumberland County (below). (Courtesy Library of Congress, Prints and Photographs Division.)

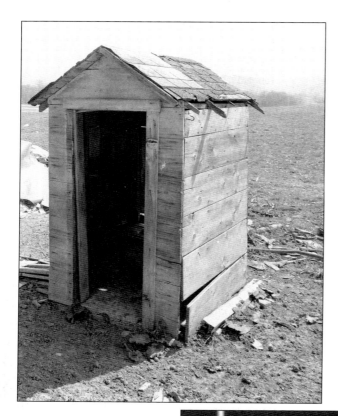

This portable privy, standing at the edge of a Burlington County bog, served over 200 cranberry pickers in the 1930s. (Courtesy Library of Congress, Prints and Photographs Division.)

With entire families spending the cranberry-picking season in the fields from early September through late October, everything, including laundry, had to be handled in and around pickers' makeshift shelters. (Courtesy Library of Congress, Prints and Photographs Division.)

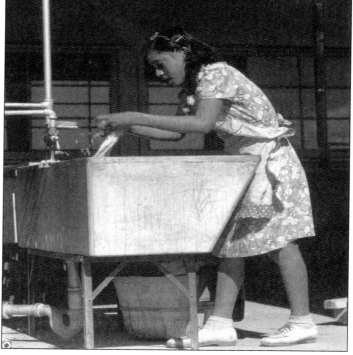

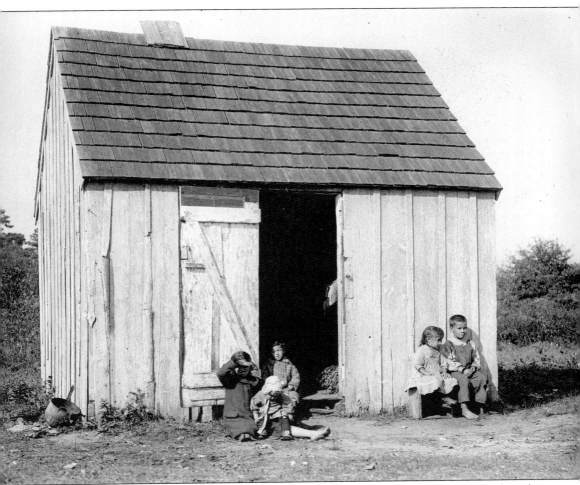

The 10-member DeMarco family, five of the children seen here getting a bit of fresh air, shared this shack for close to two months during cranberry picking season. (Courtesy Library of Congress, Prints and Photographs Division.)

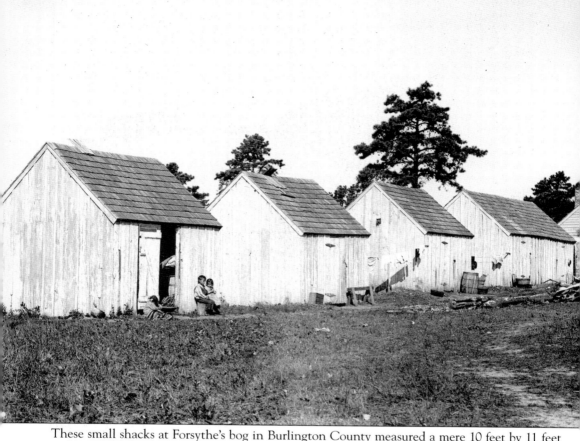

These small shacks at Forsythe's bog in Burlington County measured a mere 10 feet by 11 feet and stood 5.5 feet high. To help accommodate large families, each shack included a low, gable attic, which provided a bit of extra sleeping space for smaller children. (Courtesy Library of Congress, Prints and Photographs Division.)

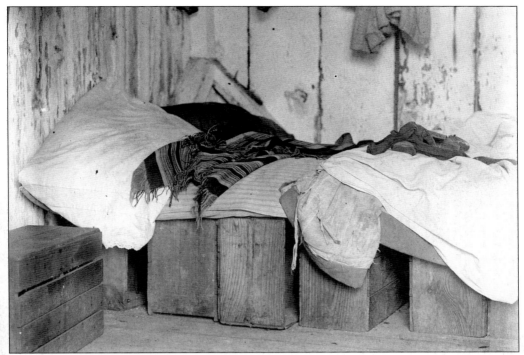

A handful of produce crates or rough-wooden bunk beds, a tattered mattress, and some stained linens make up the beds for cranberry pickers like the DeMarcos. After long hours of backbreaking work, even an unappealing bed was a welcome sight. (Courtesy Library of Congress, Prints and Photographs Division.)

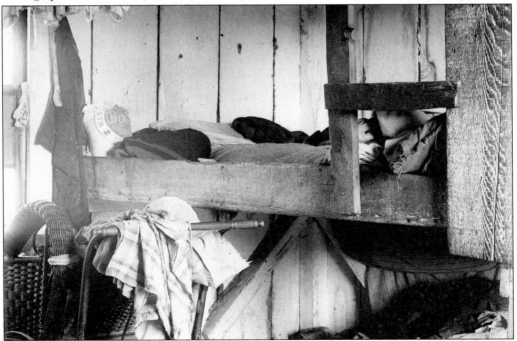

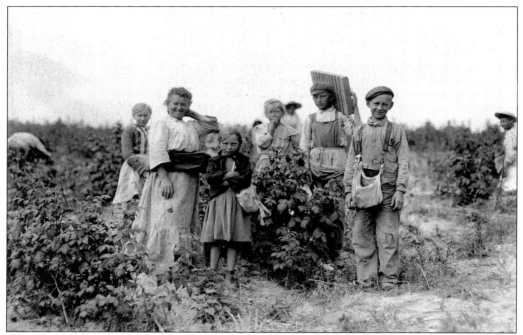

Regardless of the heat, farm laborers wore heavy clothing that covered just about everything but their hands and faces as protection from the rough work in the fields. (Courtesy Library of Congress, Prints and Photographs Division.)

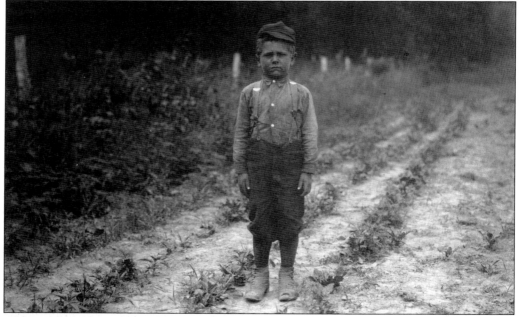

Although hesitant to do so (fearing repercussions from their parents and the field bosses), young immigrant and migrant farm laborers like this six-year-old boy did occasionally complain of long, hot days in the fields in the early part of the 20th century. (Courtesy Library of Congress, Prints and Photographs Division.)

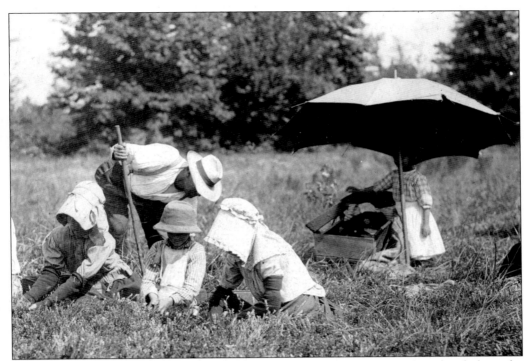

Occasionally a young girl in the fields would have the opportunity to take a break from the backbreaking work when the family's infant needed tending. In this 1910 photograph, taken in Pemberton, the child and infant were lucky enough to benefit from a bit of shade supplied by an umbrella brought to the fields for just such a purpose. (Courtesy Library of Congress, Prints and Photographs Division.)

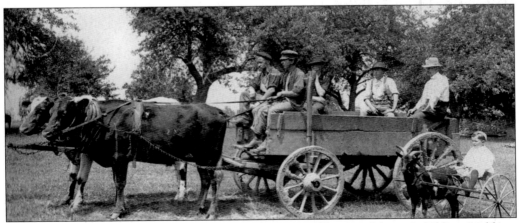

In contrast, the children of large farm owners often enjoyed luxuries laborers' children could not even imagine, for example, riding in their own personalized goat cart. This photograph, taken around 1908, shows the last oxen-drawn cart in Burlington County alongside a farm child's small goat cart on the Butterworth Farm in Vincetown.

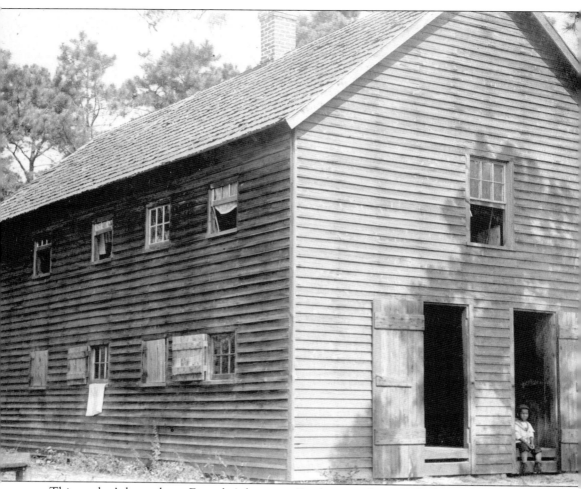

This worker's barracks at Forsythe's bog near Pemberton, photographed in 1910, contained 24 rooms, each room housing a family hired as seasonal help at the cranberry bog. (Courtesy Library of Congress, Prints and Photographs Division.)

A group of older boys, identified by the photographer as a "rough gang," hang out during the off hours at Whitesbog in Pemberton in 1910. (Courtesy Library of Congress, Prints and Photographs Division.)

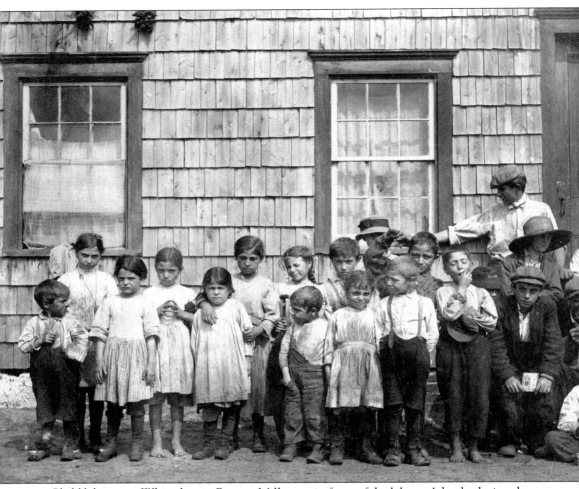

Child laborers at Whitesbog in Browns Mills pose in front of the laborers' shacks during the noon break. Although the school year is already in its fourth week, these children, ages 4 through 12, will spend two more weeks in the fields before heading home with their families. (Courtesy Library of Congress, Prints and Photographs Division.)

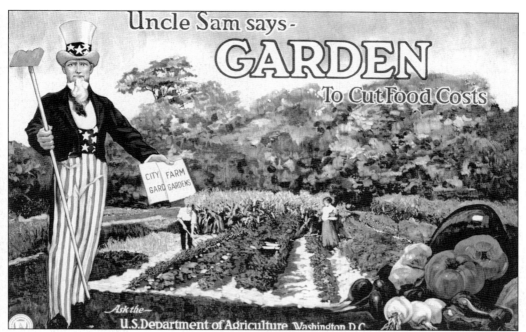

War brought farming into the forefront for all families, with the U.S. Department of Agriculture encouraging everyone to plant a victory garden, no matter how small, to help keep national food costs down. (Courtesy Library of Congress, Prints and Photographs Division.)

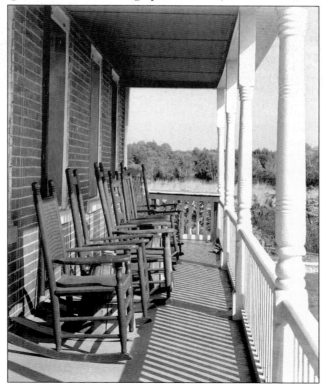

Rocking chairs beckon weary members of the family to the porch of the Amaziah Burcham farmhouse, built in 1907, on South Second Avenue in Millville. (Courtesy Library of Congress, Historic American Buildings Survey.)

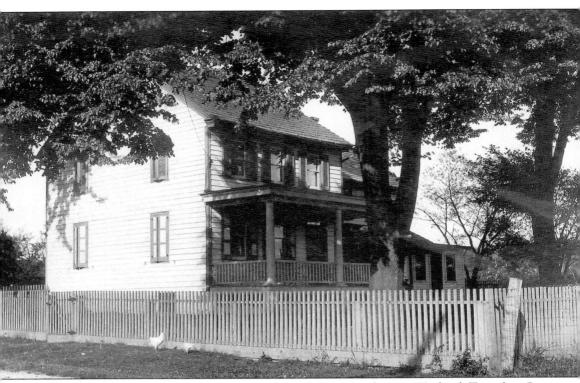

This is a view of the Howey farmhouse, known as Pleasant Meadows, in Woolwich Township. Owner Jacob Howey, surveyor, judge, and New Jersey assemblyman, was considered a gentleman farmer in his day, hiring others to tend the fields. (Courtesy Gloucester County Historical Society.)

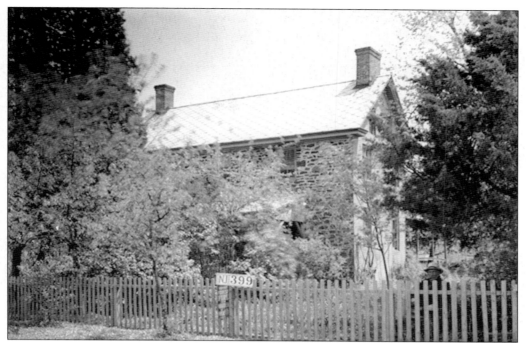

Photographed here in 1937, the Joseph Leeds House on Moss Mill Road in Atlantic County was the farmhouse of an 1813 plantation. (Courtesy Library of Congress, Prints and Photographs Division.)

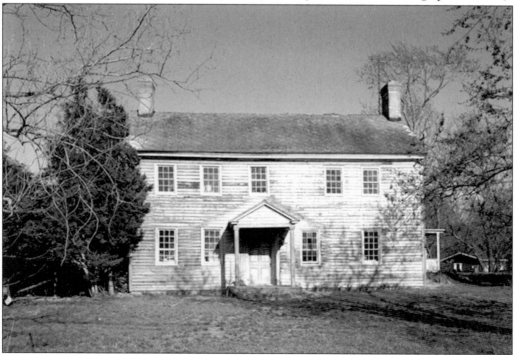

This Cape May County farmhouse stood on Route 47 in South Dennis. (Courtesy Library of Congress, Prints and Photographs Division.)

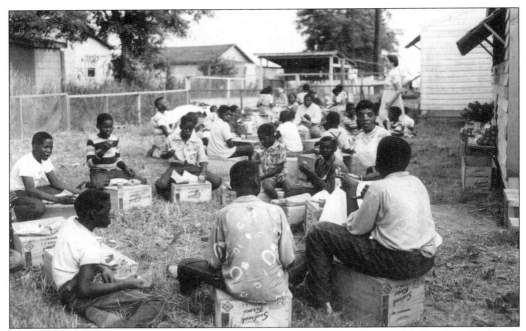

Migrant workers use asparagus boxes as tables and chairs during their lunch break at Seabrook Farms. (Courtesy Seabrook Farms Educational and Cultural Center.)

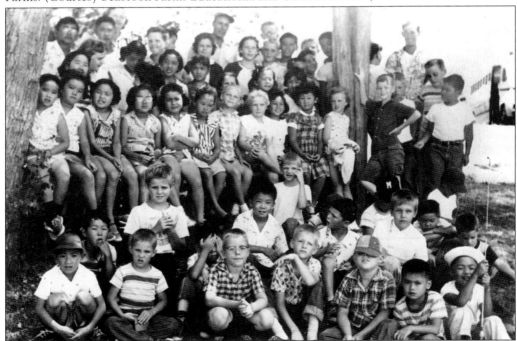

Seabrook Farms children pose for a photograph before leaving for a fun-filled day at summer camp at Clark's Pond. Generally at Seabrook, young children were provided with social and educational programs rather than being relegated to the fields all day. (Courtesy Seabrook Farms Educational and Cultural Center.)

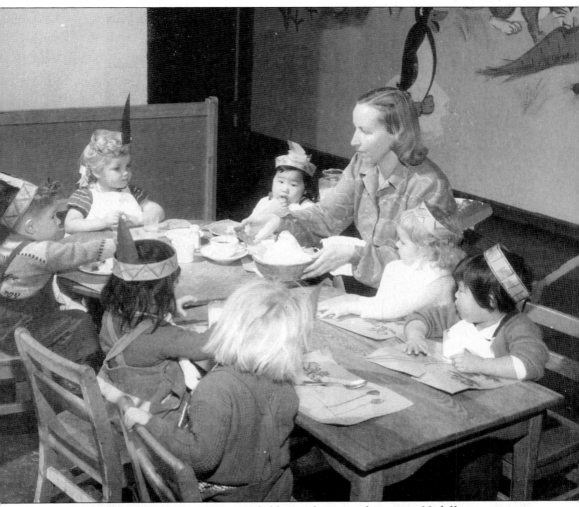

Beginning in the 1920s, Seabrook Farms children, who came from over 30 different countries and spoke a dozen different languages, were enrolled in the Seabrook Child Care Center, also known as the Seabrook Nursery School. The federally-supported center allowed parents to work different shifts without worrying about childcare. (Courtesy Seabrook Farms Educational and Cultural Center.)

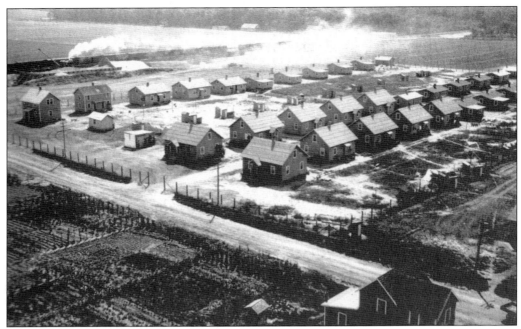

Seabrook Farms established separate villages for the various nationalities employed by the corporation, where they could speak their native languages and eat their native foods. A town center offered the opportunity for group socializing. Pictured here is the Italian village. (Courtesy Seabrook Farms Educational and Cultural Center.)

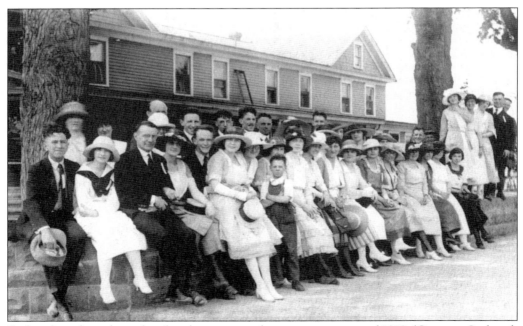

Seabrook workers, dressed in their best, pose in the town center around 1912. (Courtesy Seabrook Farms Educational and Cultural Center.)

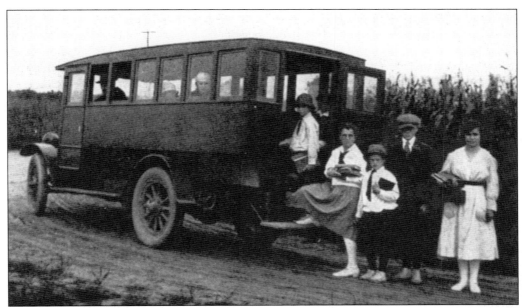

Cumberland County farm children climb aboard the local bus for a day at school. (Courtesy Cumberland County Historical Society.)

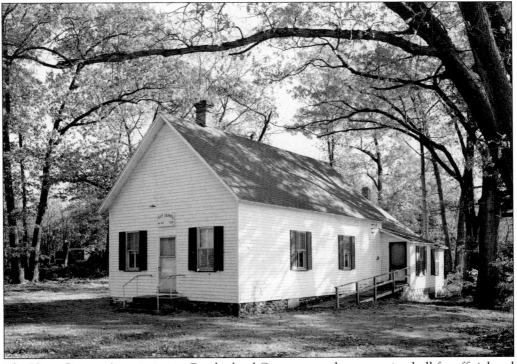

The Hope Grange Association in Cumberland County served as a meeting hall for official and social functions. When built in 1904, Hope Grange No. 43 was one of the lodges of the Patrons of Husbandry, a national organization organized in 1867 as a secret society to further farmers' interests. (Courtesy Library of Congress, Historic American Buildings Survey.)

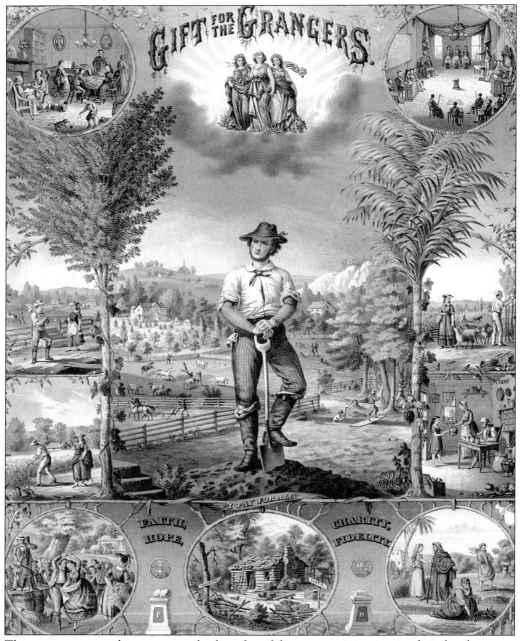

This poster was used to promote the benefits of farmers participating in their local grange. (Courtesy Library of Congress, Prints and Photographs Division.)

Six

OFF THE VINE

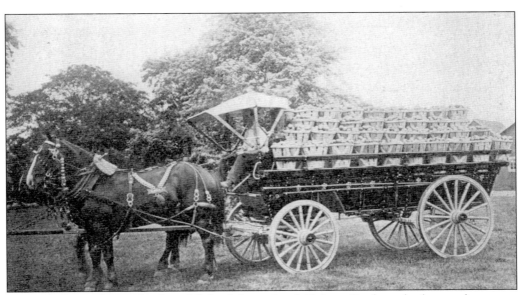

A South Jersey farmer hauls a full load from the field in a Frech underslung-style wagon, manufactured by William Frech of Maple Shade. Sitting six inches lower than traditional wagons, it was far easier to load and unload, promising quicker work runs to and from the field. (Courtesy Camden County Historical Society.)

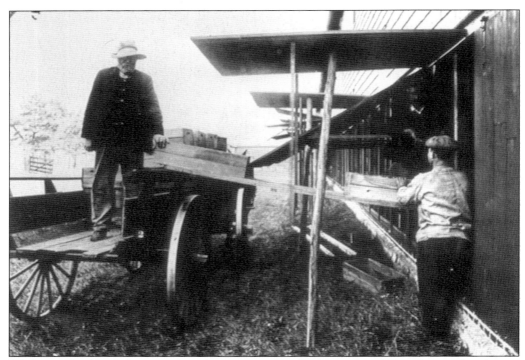

Workers unload bushel crates of cranberries into the side doors of the Whitesbog packinghouse, while inside women sort the berries into wooden barrels for shipment. (Courtesy New Jersey Conservation Foundation.)

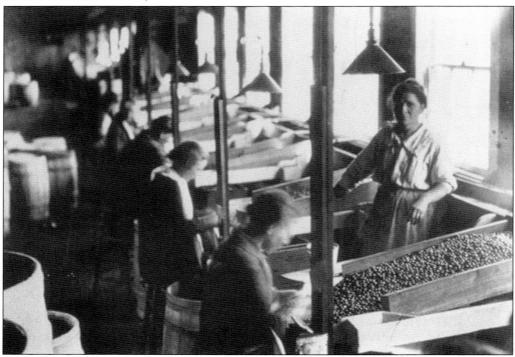

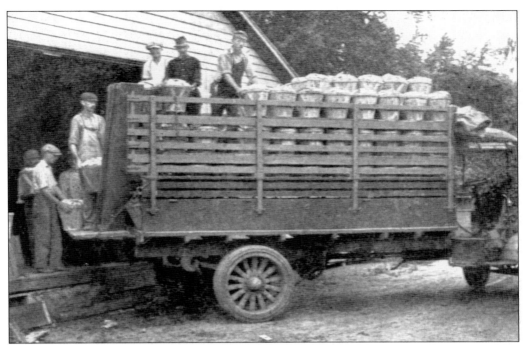

Cumberland County peaches head for a storage garage to await shipping to the city markets. (Courtesy Cumberland County Historical Society.)

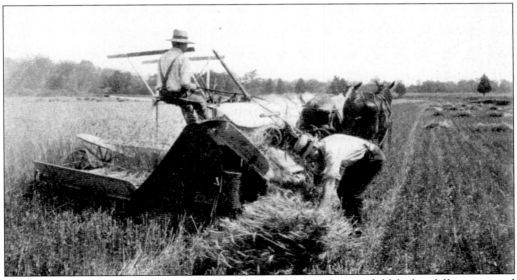

Farmers machine-cut and hand-gather wheat in a Burlington County field, before fully automated harvesting became available. (Courtesy Camden County Historical Society.)

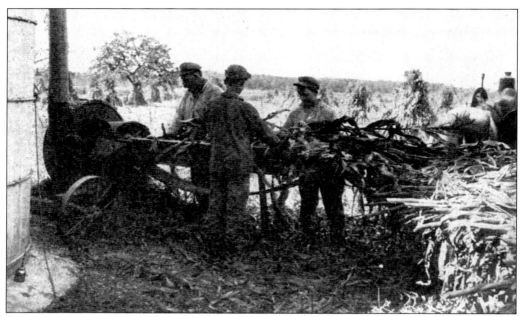

Farm laborers work at a cutter, preparing corn for silo storage at a Burlington County farm. (Courtesy Camden County Historical Society.)

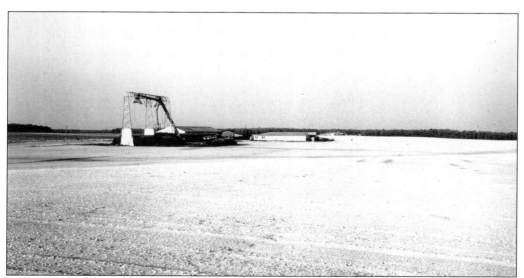

Beans are hauled from the field to this Seabrook Farms canning factory in the field for processing. (Courtesy Seabrook Farms Educational and Cultural Center.)

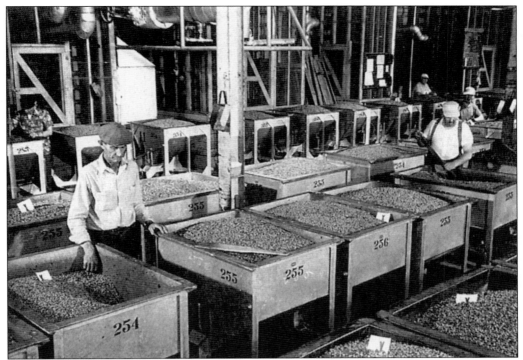

Workers check Seabrook Farms peas in hoppers before they begin the trek through washing, blanching, sorting, and freezing. (Courtesy Seabrook Farms Educational and Cultural Center.)

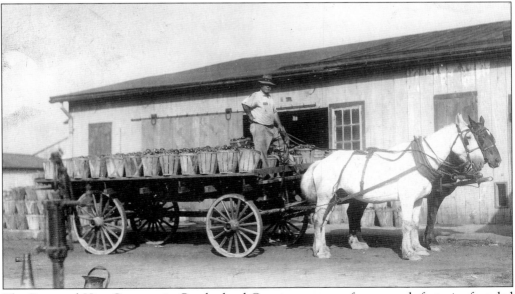

The Fogg and Hire Cannery in Cumberland County was one of many such factories founded in South Jersey in the 1860s as production began increasing on area farms. Tomatoes, like the ones loaded on the wagon of this local farmer, were a favorite crop for canning and were the first produce put up by canning pioneers in the early 19th century. (Courtesy Camden County Historical Society.)

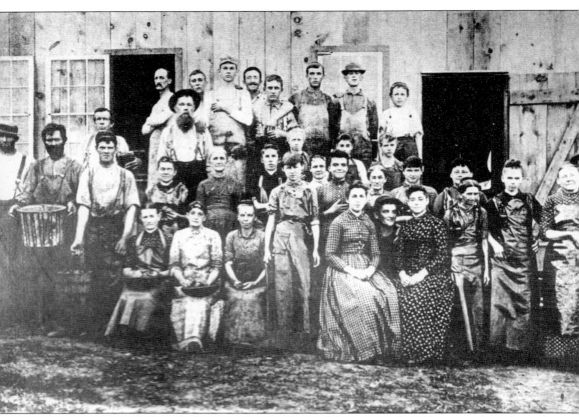

Canneries provided work for many locals. Pictured here around 1888 are workers from the William L. Stevens and Brothers Can House in Cedarville. (Courtesy Cumberland County Historical Society.)

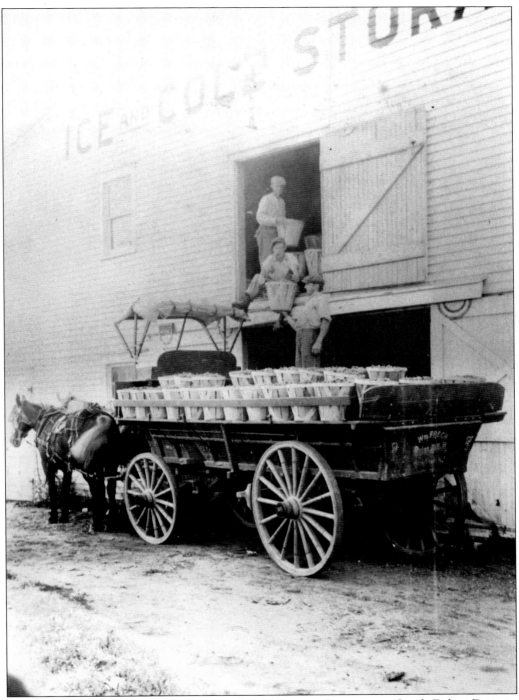

Local produce is loaded into Repp's Ice and Cold Storage Company on South Delsea Drive in Glassboro around 1915. (Courtesy Gloucester County Historical Society.)

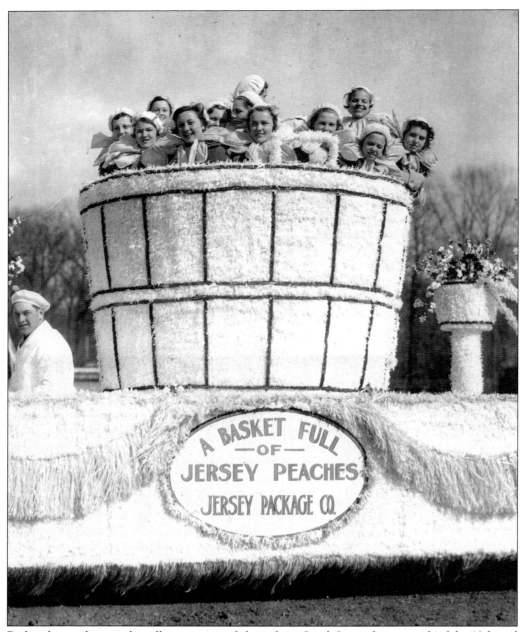

Packinghouses large and small were scattered throughout South Jersey during much of the 19th and 20th centuries. This float, entered into a Salem County parade, pays tribute to a favorite crop, Jersey peaches, and one local packinghouse, the Jersey Package Company. (Courtesy Camden County Historical Society.)

Seven

TO MARKET, TO MARKET

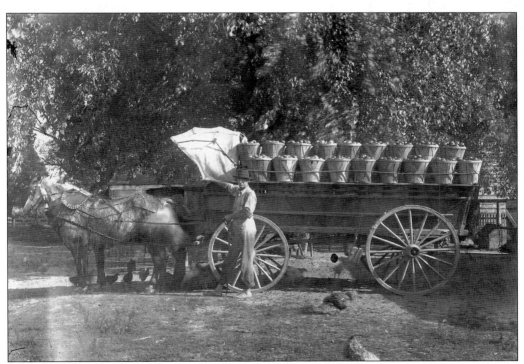

A Gloucester County farmer prepares to haul his load of tomatoes to market in the early 1900s. Produce was regularly transported by horse-drawn wagons early in the morning, before the heat of the day could take its toll on the delicate perishables. (Courtesy Gloucester County Historical Society.)

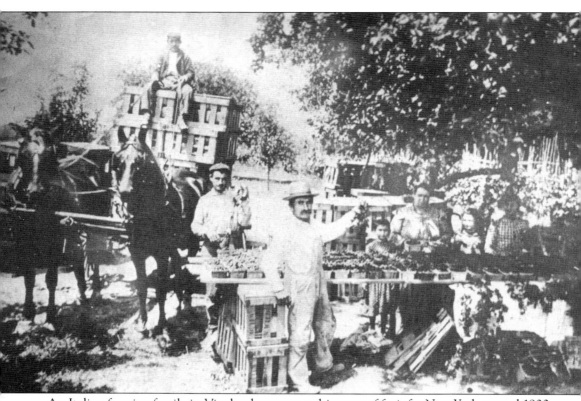

An Italian farming family in Vineland prepares a shipment of fruit for New York around 1900.

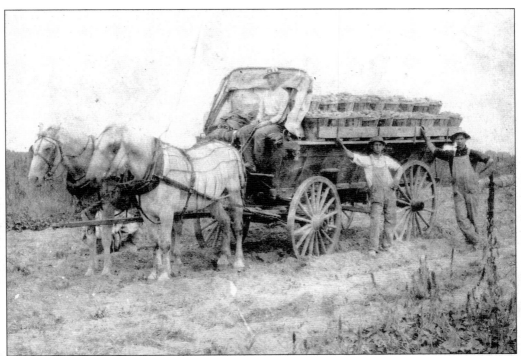

Orville Stetser (seated), Joe Calloway, and Walt McKedrick prepare to haul a load of tomatoes from the fields at Brewer's Farm in Chews Landing on Mount Ephraim-Blackwood Turnpike in 1913. Farmers often had to make several trips in a day because their wagons could only accommodate a small amount of the perishable produce at a time. (Courtesy Gloucester County Historical Society.)

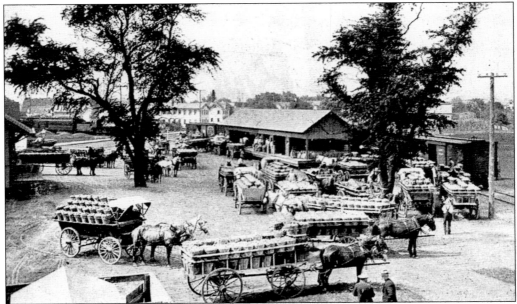

Local farmers pull into the Elmer produce auction with loads of potatoes available for sale.

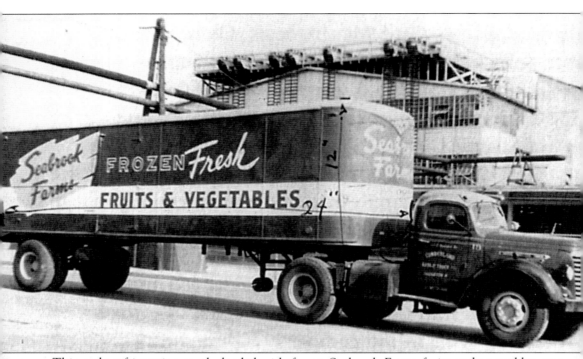

This early refrigeration truck, loaded with frozen Seabrook Farms fruits and vegetables, was a common sight on the nation's roadways in the 1950s and 1960s. (Courtesy Seabrook Farms Educational and Cultural Center.)

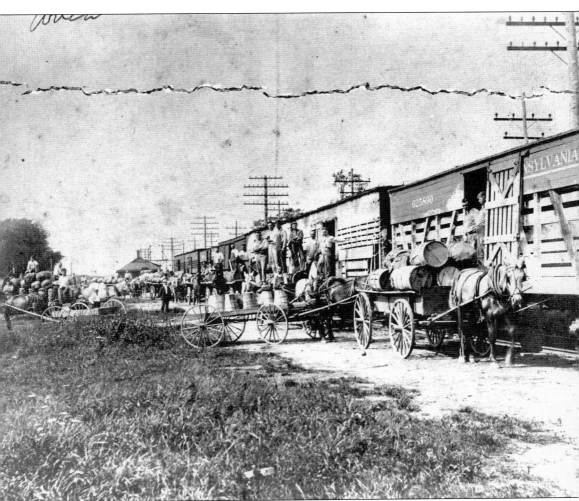

Ventilated railroad cars loaded with produce in the Malaga section of Franklin Township stand ready to roll in 1911. Before refrigeration was available, these airy containers provided the best means of shipping perishables and were loaded to capacity with barrels and bushels transported to the railroad station by farmers in horse-drawn wagons. Produce that was shipped in the morning usually reached kitchen tables that same evening. (Courtesy Gloucester County Historical Society.)

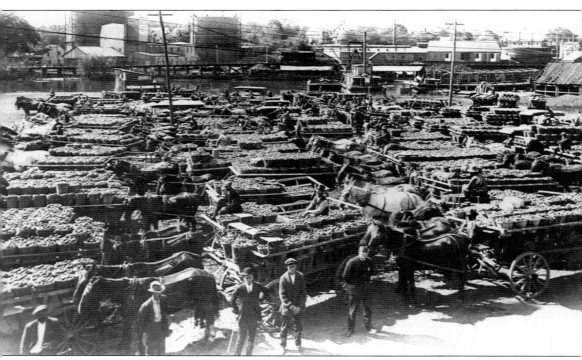

South Jersey farmers wait in line to deliver tomatoes to Campbell Soup Company in Camden around 1910. The wagons, each carrying between three and four tons of produce, lined the city's streets from late summer through the end of October. With the first farmers arriving before daybreak along Second Street, the line of traffic reportedly often stretched for nine miles. (Courtesy Campbell Soup Company.)

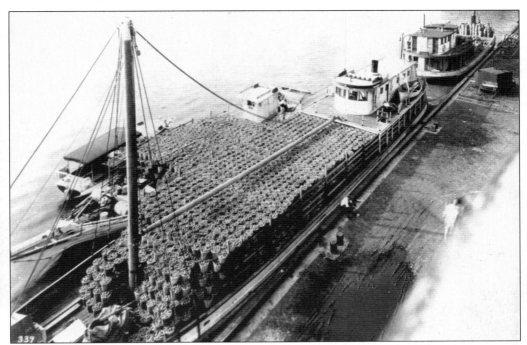

Campbell Soup Company contracted with an estimated 2,000 area growers for tomatoes each year. In this early-1930s photograph, a load of tomatoes arrives by barge along the Delaware River docks in Camden. (Courtesy Campbell Soup Company.)

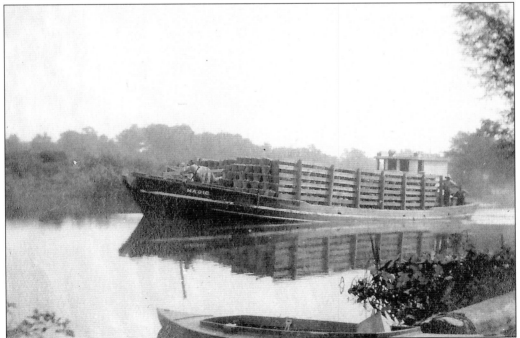

Tomato boats carrying cargo to Baltimore's canneries are loaded from the wharf near Green's Lumberyard in Mount Royal in 1914. (Courtesy Gloucester County Historical Society.)

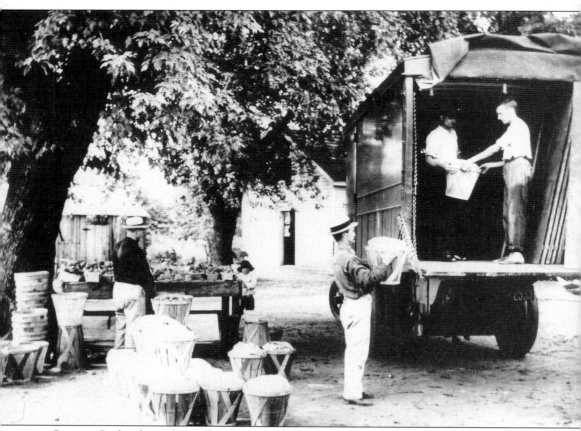

Stanger Orchards produce is loaded onto a Repp's Ice and Cold Storage Company truck parked at the back of Samuel Magee's house on Delsea Drive in Glassboro around 1915. (Courtesy Gloucester County Historical Society.)

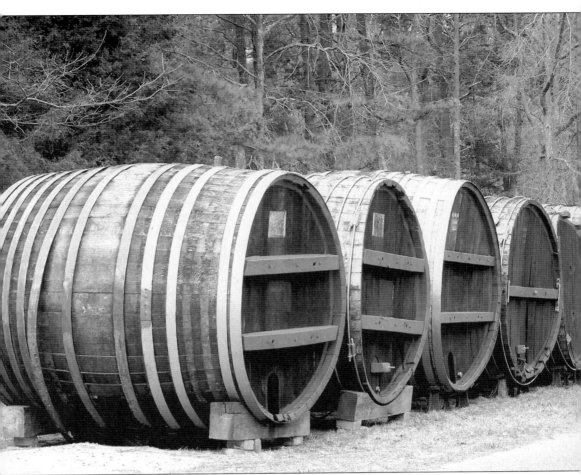

These giant wooden casks were used to store wine at the Renault Winery in preparation for market.

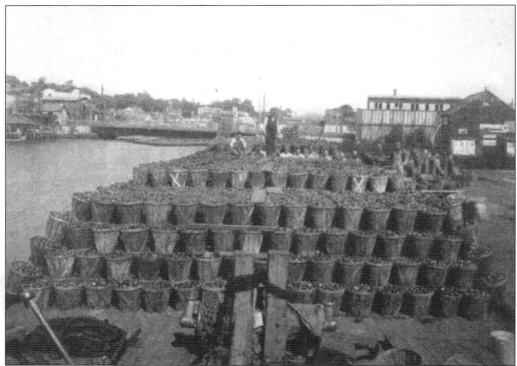

Tomatoes stand ready for market in Cumberland County. (Courtesy Cumberland County Historical Society.)

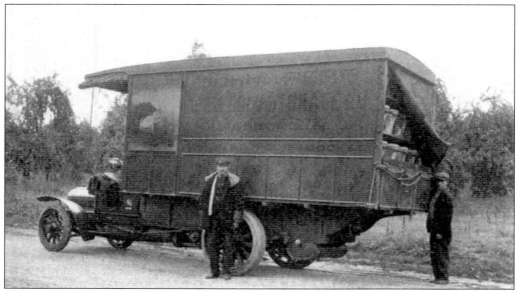

This box truck, the finest form of transportation in its day, was owned by a Burlington County farmer, pictured here on his way to deliver fresh produce to Philadelphia. (Courtesy Camden County Historical Society.)

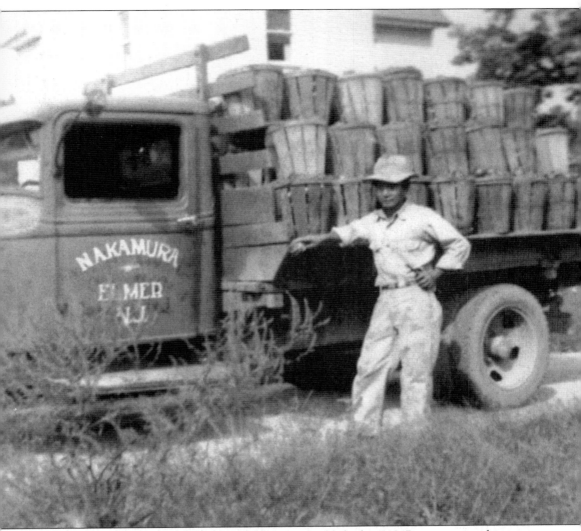

The Elmer farm of Kiyomi and Ellen Nakamura, established in 1947, prepares a shipment for market.

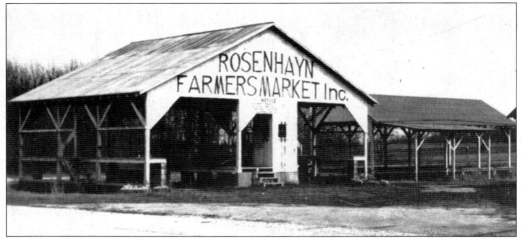

Roadside farm markets ranged in size from small shacks to large-scale operations. The Rosenhayn Market was established in the Atlantic County Jewish farm settlement of the same name. The Maple Shade Market served customers in Cumberland County. (Above, courtesy Library of Congress, Prints and Photographs Division; below, courtesy Cumberland County Historical Society.)

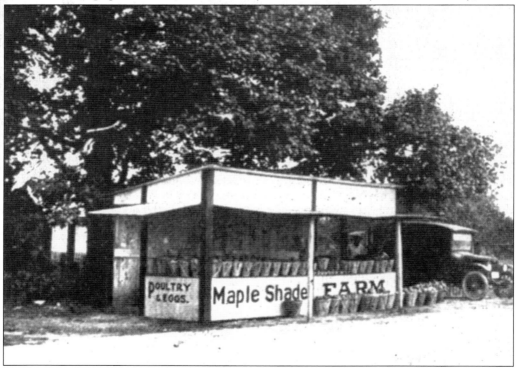

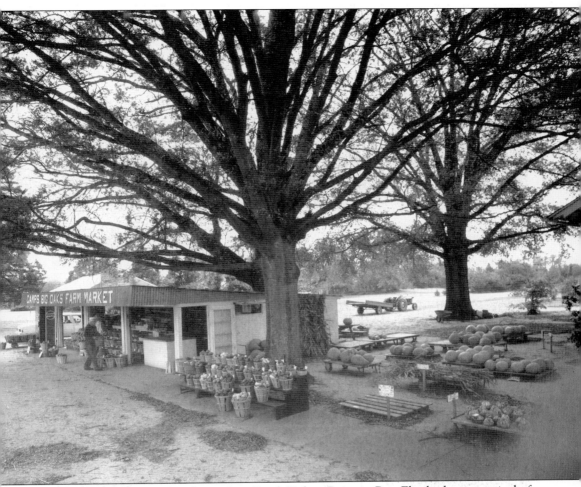

Camp's Big Oaks Farm Market, located on South Delsea Drive in Port Elizabeth, was typical of the roadside stands that began springing up in South Jersey when the automobile began gaining popularity in the 1920s. Hise Camp, a local farmer, started the stand as a temporary operation. By the time his son Ken took over the stand, it was a full-time business. (Courtesy Library of Congress, Historic American Buildings Survey.)

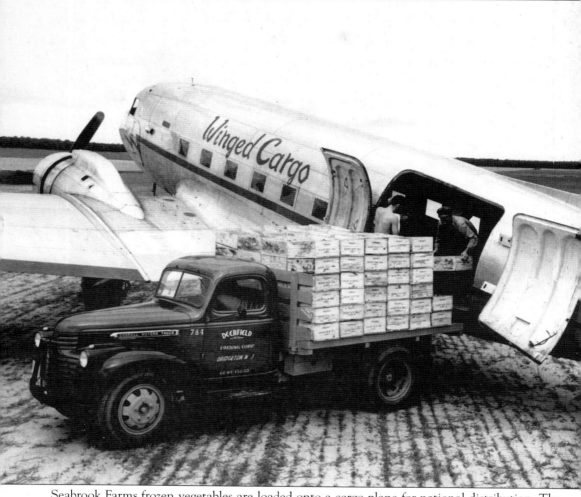

Seabrook Farms frozen vegetables are loaded onto a cargo plane for national distribution. The company was once the largest processor of frozen foods in the world. (Courtesy Seabrook Farms Educational and Cultural Center.)